LIZZIE KING

TIE & DYE

PAVILION

CONTENTS

FOR DOREEN, MY BRILLIANT GRANDMA

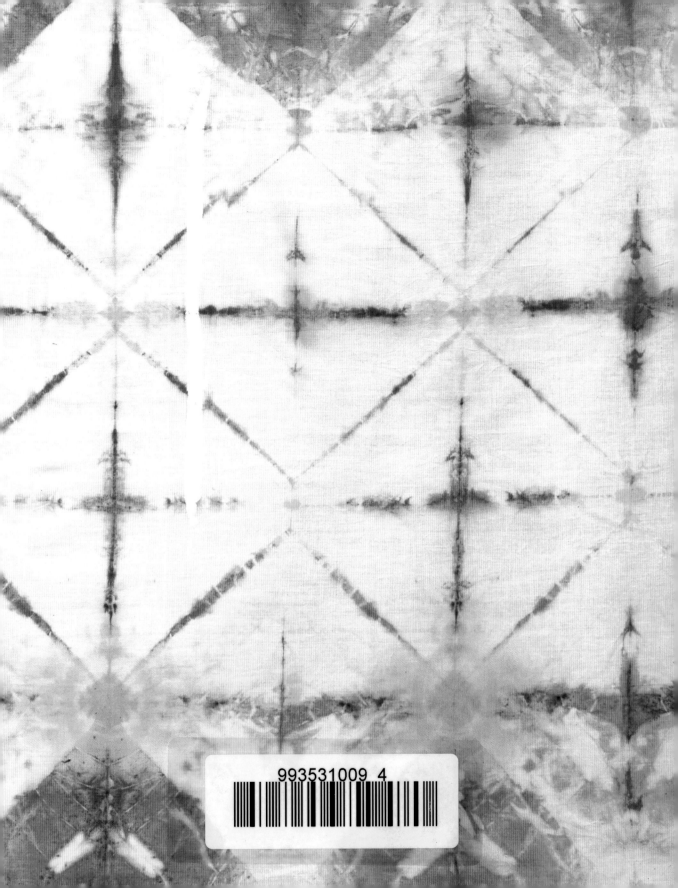

993531009 4

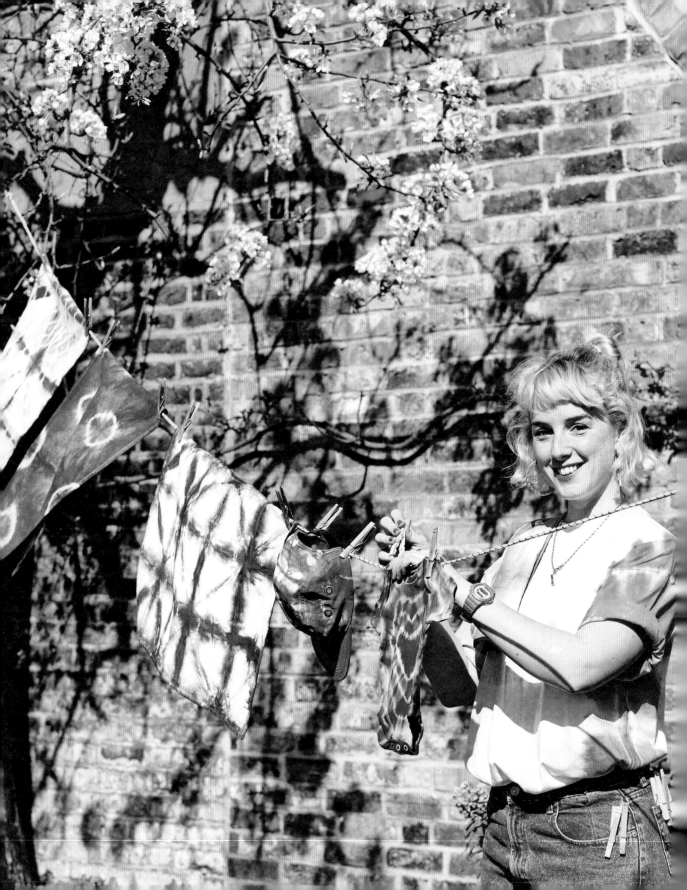

GET RICH OR TIE-DYEING!

" SAY YES FIRST, THEN WORK OUT HOW TO DO IT LATER "

When I was growing up, this was my dad's favourite motto. This is exactly what he did when he was hired as an IT expert in the 1980s despite knowing nothing about computers. It was with this advice ringing in my ears that I agreed to tie-dye some white shirts for clothing brand Brutus Trimfit in the summer of 2012. I had never used dye before, but I was just starting out on my own and really keen for any kind of creative freelance work. I watched about an hour of YouTube tutorials and found an amazing guy called Colorful Steve who made it all sound so easy. I eagerly jumped on my bike and cycled to the nearby craft shop to buy dye. I was ready to go!

I tried my first ever tie-dye on one of the six shirts Brutus had given me. As soon as I began, I realised I should have practised on an old T-shirt. I had no idea how messy it could be. Very quickly there were rivers of pink, blue and yellow dye appearing all over our uneven, wonky warehouse floor, pooling into brown puddles. The colours on the first shirt I dyed clashed in a way that made you feel like you needed a pair of sunglasses to look at it!

Even though my first experiments were a disaster, I was hooked by the thought of being able to transform an old rag into something colourful and fresh. My next chance came when a brave friend asked me to dye some old YSL white shirts. This time I did some experiments and tried out the dye on scraps of white fabric before squirting them all over the shirts. I used the swirl technique (see page 48) on both, using a pastel colour palette on one and tropical colours on the other. When I opened up the shirts, the results made me do an out loud 'OOOH!'. This was the start of my obsession. Soon I was tie-dyeing duvet covers, hammocks, socks, shoes, underwear. Nothing in my house was safe!

I posted some photos of my work on Instagram and was surprised to receive an email the same day from a bar in Shoreditch that wanted to run some tie-dye workshops. This was the beginning of my 'Get Rich or Tie-Dyeing' workshops. I loved introducing people to the magic of tie-dye. In the three years since, I have run workshops for different brands, schools, charities, galleries and members' clubs.

" MY THRIFTY SIDE LOVES MAKING SOMETHING OUT OF NOTHING...
 IT'S ALMOST AS IF YOU'RE MAKING MONEY. YE£$ BO$$ "

DO IT YOURSELF

In this book I have put together my favourite projects to give you a real taster of all the exciting possibilities of tie-dye. Hopefully after trying a few of my ideas you will also find yourself hooked on transforming ordinary, plain white garments that might have seen better days into something new and exciting!

The wonderful thing about tie-dye is that you can't really get it wrong. It might not come out exactly as you imagined but every time you try something you will learn a bit more about how tie-dye works.

One of my favourite things about tie-dye is that the results are not instant. The wait to reveal your design really adds to the fun. There aren't many things you have to wait for in this instant internet age – it reminds me of the nice anticipation of getting a film developed after a brilliant party or sunny holiday.

CHILD'S PLAY

Tie-dye is a really great activity to do with children. Toddlers have come to my classes with their parents and happily squirted dye all over T-shirts. It's a really fun visual way of being creative with younger children, especially to help them learn about colour mixing. You don't have to be precious or precise, so they can have fun and create without worrying about being neat. Whenever I do tie-dye workshops in schools, the levels of excitement always surprise me.

TIE-DYE BASICS

Tie-dye has been practised for hundreds of years by people all over the world. It isn't hard to understand why – it is such a simple technique that produces brilliant results. No one is sure where and when tie-dye originated from, or if it was in fact a happy accident! Early records show dyed cloth from India that dates back to the sixth century AD. Traders on the old caravan routes through Asia, India and the Far East took tie-dyed fabrics to sell as part of their merchandise.

For many people tie-dye conjures up images of hippies in the 70s, with their psychedelic colours and rainbow patterns. It is amazing to think that these fashions originated from a technique first used over 1000 years ago!

ELASTIC BANDS ARE PARTICULARLY GREAT AT RESISTING DYE

The basic principle of tie-dye is to create parts of the fabric that will not be dyed – that resist the dye. The patterns made by the dyed fabric contrast with the original colour of the fabric – the areas that have resisted the dye.

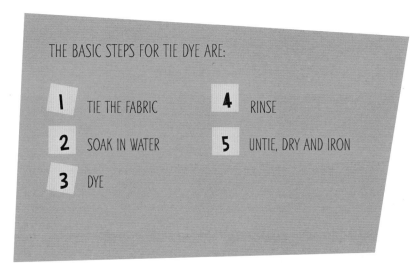

THE BASIC STEPS FOR TIE DYE ARE:

1 TIE THE FABRIC

2 SOAK IN WATER

3 DYE

4 RINSE

5 UNTIE, DRY AND IRON

SHIBORI

Traditionally, shibori is made on white fabric that is dyed using indigo dye. The white patterns contrast in a really nice way with the dark blue. Indigo is a naturally occurring dye, but you can also buy synthetic indigo easily now. The dye itself will look yellowy green when mixed up, but when the submerged fabric is taken out of the dye bath, it will slowly turn dark blue as the dye oxidises. Indigo dye can be a bit tricky and unpredictable, so in this book I have substituted it for Dylon Jeans Blue hand dye. If you do fancy trying out the real deal then you can buy indigo starter packs cheaply on the internet.

Translated loosely from Japanese, 'shibori' means 'to wring, squeeze or press'. The fabric is stitched, folded or clamped before being submerged in a vat of indigo dye. The process results in very intricate shapes and patterns. You can be much more precise than with tie-dye, particularly when using the stitching technique. I loved this method: the first time I used it to create a wiggly line I was blown away by the shapes that you can create using simple stitches.

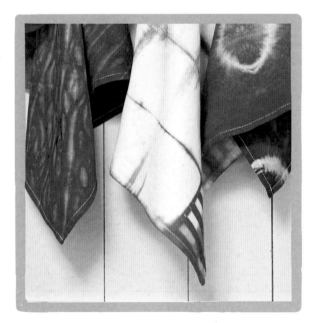

IT IS EASY TO TELL SHIBORI FROM TIE-DYE: SHIBORI IS USUALLY DARK BLUE WITH WHITE PATTERNS

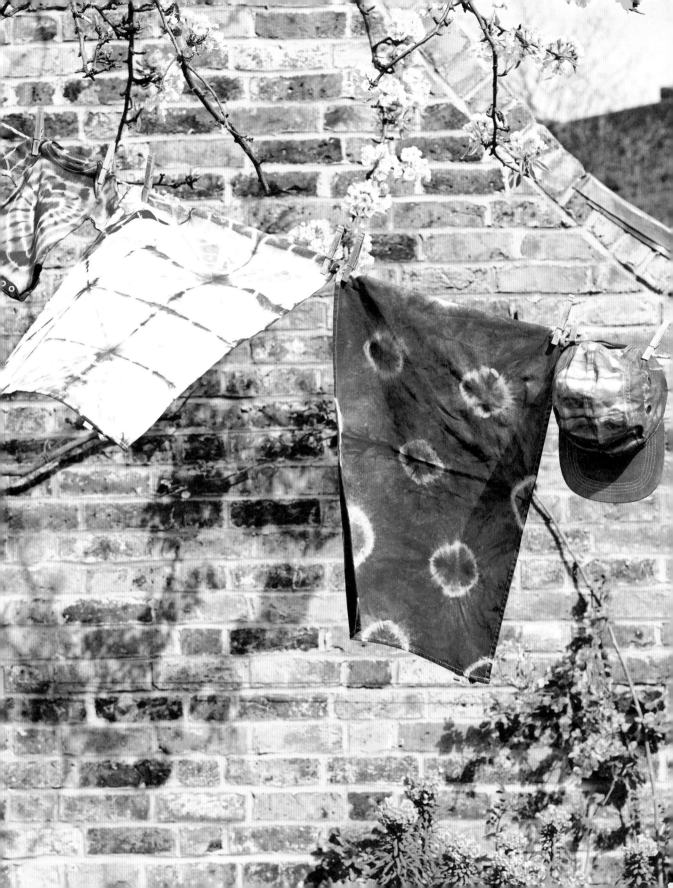

DYES

I remember buying the old-school Dylon dyes that came in small metal tins. They had every shade imaginable; one that sticks in my memory was Reindeer Beige – I have a phobia of beige! The packaging was quite hard to use as you had to pierce the tin. I always got in a terrible mess and dyed my fingers. I was sad when the range changed and there were much fewer shades on offer; however, the new packets are much easier to open and it is easy to mix shades using the more streamlined range.

Throughout the book I have used Dylon hand dye. I like the colours, they are easy to mix up and the colours stay strong even after lots of washes. You can buy Dylon from most fabric shops and haberdashery sections in department stores. They come in powder form, so you simply mix them with hot water and salt.

I love how Dylon dyes mix together. It's easy to create colours if you can't find the shade you want. If you use Flamingo Pink, Sunflower Yellow and Bahama Blue you can mix really lovely turquoise greens, a deep violet and great oranges. In the colour wheel on page 14 I have shown the colours you can make when you mix these three dyes. A good example of this is the Swirly swirl T-shirt (right).

I also like Rit dyes; they are really vibrant and give a great depth of colour. They are sold as a liquid, so you just add hot water and salt. They come in more shades than Dylon dyes so might be better if you don't want to mix your own colours.

THIS T-SHIRT ONLY USES THREE COLOURS (FLAMINGO PINK, SUNFLOWER YELLOW AND BAHAMA BLUE) BUT WHEN YOU OPEN IT OUT YOU HAVE A RAINBOW SWIRL!

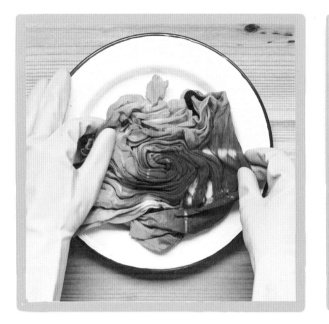

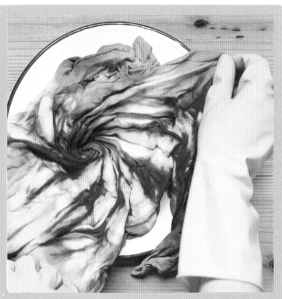

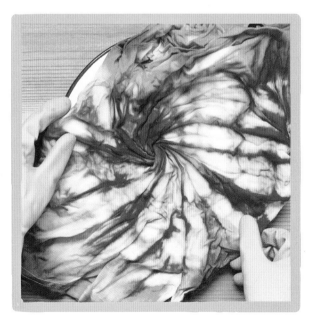

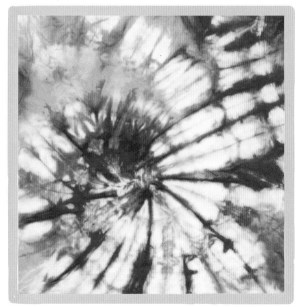

COLOUR WHEEL

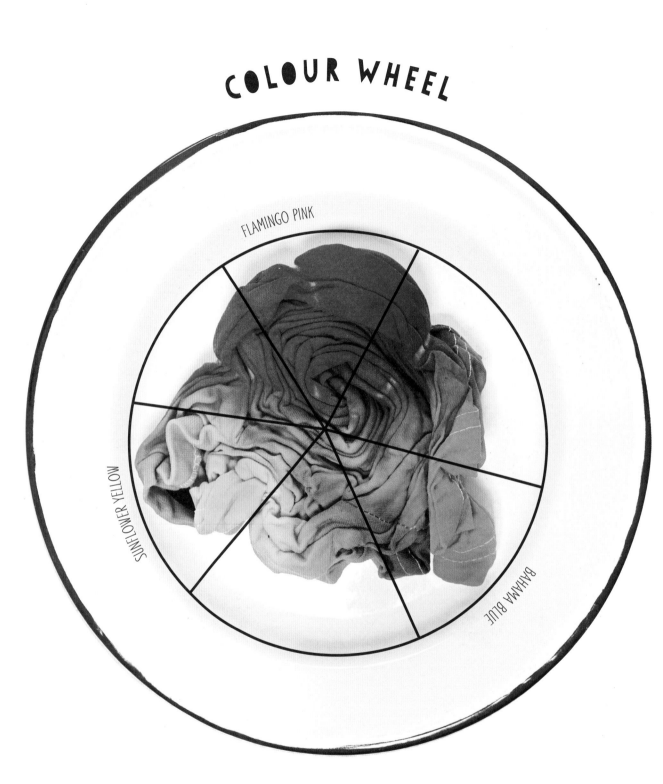

FLAMINGO PINK

SUNFLOWER YELLOW

BAHAMA BLUE

One of the first things I teach at my workshops is the colour wheel. It is completely understandable that we forget how to mix colours – for lots of people the last time they mixed any colours was at primary school.

The primary colours are red, blue and yellow.

PRIMARY COLOURS

You cannot make these colours.

These three colours can be mixed together in different combinations to make all other colours.

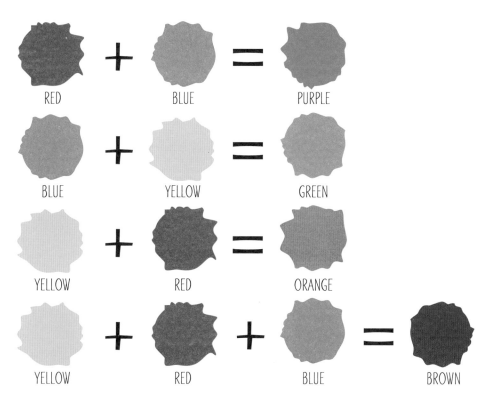

RED + BLUE = PURPLE

BLUE + YELLOW = GREEN

YELLOW + RED = ORANGE

YELLOW + RED + BLUE = BROWN

IT IS IMPORTANT TO REMEMBER THAT WHEN ALL THE PRIMARY COLOURS MIX TOGETHER, THEY MAKE BROWN!

It is easy to make brown by accident! If you dye a T-shirt purple with yellow stripes, the place where the dyes meet will be brown. Purple = red + blue, so when you add yellow = brown.

MIXING DYES

The first time you mix dyes make sure you have everything you need before you start: scissors to cut open the packet, rubber gloves to protect your hands, a spoon, salt, a jug to mix the dye in and hot water. I recommend using hot water from the tap instead of water from a kettle because of the risk of burning yourself from the boiling water.

Once you have mixed dyes a few times you won't need to follow the exact instructions and will get a feel for the right ratios. Always keep some scraps of white cotton fabric around to try out your dye on before squirting it all over your project. Before you start, make sure you put your rubber gloves on!

SQUEEZY BOTTLES

When I worked out you could pour the dye on with these, it changed the whole process for me. You can be so much more precise with where the dye goes. This is the most common technique used in the book. It is used for:

- SUNSET CUSHION COVER (PAGE 22)

- CARNIVAL SOCKS (PAGE 34)

- A TRIO OF T-SHIRTS (PAGE 42)

- 'PUMP UP THE JAM' PUMPS (PAGE 54)

- FRESH PRINCE SHIBORI CAP (PAGE 60)

- 'LOVE IS ALL YOU NEED' BABY GRO (PAGE 64)

- TOTALLY TROPICAL WATERMELON BUNTING (PAGE 86)

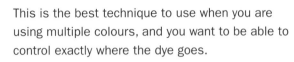

This is the best technique to use when you are using multiple colours, and you want to be able to control exactly where the dye goes.

As you are pouring the dye straight onto the fabric and not leaving it in a dye bath, you need to mix up the dye with less water than the packet advises. I recommend mixing a tablespoon of dye and a tablespoon of salt together with 350ml (1½ cups/12 fl. oz) water in a jug. This should fit into your squeezy bottles, but you may have to experiment.

Remember to try out the colour on a scrap of damp cotton fabric to check it isn't too light or dark. After rinsing and drying the fabric, the colour will be lighter than it looks now (when the fabric is damp), so mix the dye to be a bit darker than you want the finished colour to be. If you mix a colour and it's darker than you wanted, you just need to add some more water to dilute it.

Pour the dye into your squeezy bottles and apply to your fabric following the project instructions.

PIPETTE

When you are working with smaller quantities of dye, you may find it useful to use a pipette to drop the dye onto the fabric. I have suggested doing this for the Rainbow rainy day laces (page 28). If you are using a pipette, follow the instructions for the squeezy bottle technique, but instead of pouring the dye into bottles, pour it into smaller containers. Yoghurt pots or washed out takeaway coffee cups are useful for this as dye can stain ceramic mugs and bowls.

DYE BATH

This technique is used when you are working with just one colour. You are going to submerge the fabric completely in the dye so you will need to make sure that your dye bath (I usually use a bucket) is large enough to fit the project you are working on. For a large item, like the Shibori wiggle wave duvet cover (page 98), you may need to use more than one packet of dye. I have used this technique for:

- SASSY SHIBORI TEA TOWELS (PAGE 70)

- DIP DYE PLANT HANGER (PAGE 80)

- SHIBORI GRID PILLOWCASES (PAGE 92)

- SHIBORI WIGGLE WAVE DUVET COVER (PAGE 98)

Mix up the dye according to the instructions on the back of the packet. Pour the dye into the bucket and lower in the fabric. You should usually leave fabric in a dye bath for at least an hour, stirring every 10 minutes or so to make sure all of the fabric comes into contact with the dye. Follow the individual project instructions for timings.

WASHING OUT DYE

Twelve hours is the minimum time you should leave dyes on fabric before washing, to make sure the dye really sinks in. If you wash it out after less time then the colours will be lighter and look washed out. If you leave it longer than 12 hours, not much happens, just don't leave it so long that it starts to go mouldy!

ACCORDION FOLD

This is a really simple technique that is the basis for many different types of tie-dye and shibori. Once you master this technique you can adapt it to create many different results.

You simply fold the fabric as if you were making a paper fan. It is really important to remember to flip the fabric over after each fold. If you don't do this then the first fold ends up being rolled into the middle in a sausage roll type scenario, meaning that the dye won't be able to get through all the layers of fabric.

You can use an accordion fold in one direction, then fold the fabric again in the other direction to create a grid pattern. You can also use this technique to create a fan shape.

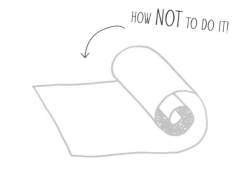

HOW NOT TO DO IT!

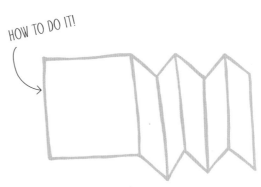

HOW TO DO IT!

MY TIPS FOR TIE-DYE SUCCESS

1 Dye is absorbed better by natural fibres. Cotton, linen, silk and wool all work well. Always check the labels of things you want to dye. If it is a natural/synthetic mix then you want the natural fibres to make up at least 50% of the fabric.

2 You cannot dye coloured fabric white.

3 If you are tie-dyeing coloured fabric remember that colour mixing rules still apply. Blue dye on yellow fabric will make green.

4 If you are dyeing something bought new from a shop then wash it first. The dye will be absorbed better.

5 Don't wear your Sunday best! Dye is made for dyeing fabric permanently. Don't underestimate the power of dye. It does tend to splash about. An apron will protect your clothes.

6 Always wear rubber gloves. Fabric dye also dyes skin. I often have blue/purple/pink hands which lasts for a few days, especially around the fingernails, which is not a strong look. It also is an irritant so best to keep those marigolds on, even when you're rinsing out the dye.

7 Get a plastic tablecloth to protect your tabletop. If you are dyeing over a white carpet (risky!), I would cover it with a plastic sheet – the kind you use for decorating. Even if you are really careful, dye can splatter, so it's better to be protected than ruin your carpet or wood floor. Dyeing is a great outdoor activity!

18

8 Use squeezy bottles to apply dye to fabric (see page 16) – the kind you get ketchup and mustard in when you go to a greasy spoon café. You can buy these in pound shops which brings me on to my next top tip…

9 Pound shops! My favourite place to shop. You can get almost everything you need to tie-dye cheaply there: elastic bands, disposable plastic gloves, salt, buckets, squeezy sauce bottles, sometimes even dye. I love these places, you never know what you will find.

10 Use normal cheap salt for dyeing – you don't need the expensive specialist dye salt. The salt opens up the pores of the fabric so that the dye can be absorbed.

11 Get everything you need together before you start. Mixing up all the dyes you need in one go makes the whole process run smoothly. Sometimes when you are dyeing something you feel like you could do with another pair of hands, but if you set everything out within reaching distance it is much more enjoyable…

12 Have a plastic bag on hand ready to put your tie-dyed creation into; this means you won't be walking around dripping dye everywhere searching for a bag! Sandwich bags are great as they seal securely. I always use these for workshops where people are travelling home with their tie-dye.

13 When cutting off elastic bands, threads or string, use stitch rippers or small scissors. It's really easy to cut the fabric accidentally. Often if you buy a tie-dyed garment in a shop they will have a 'disclaimer' label in them to say any holes are a product of the dyeing process and add to the authenticity. If you like the holey look, then you don't need to be so careful!

14 Don't pour dye into scratched enamel sinks. The dye can stain the scratches.

15 Finally – have fun! The beauty of tie-dye is that you can create something new, cheaply and quickly. Try not to be too exact. Projects that have gone 'wrong' have sometimes taught me new, exciting techniques.

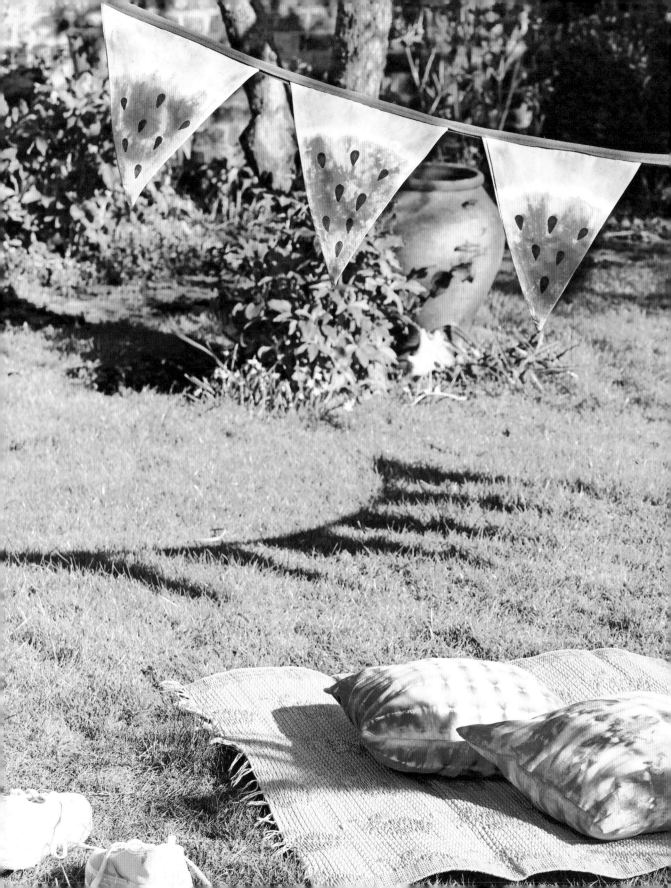

DO IT YOURSELF!

SUNSET
CUSHION
COVER

〜〜〜
〜〜〜

THIS IS ONE OF THE EASIEST PROJECTS IN THE BOOK. I LOVE HOW
THIS CUSHION LOOKS LIKE A COLOUR GRADIENT FROM A TROPICAL
SUNSET. IT'S PERFECT FOR TRANSFORMING YOUR SOFA INTO
SOMEWHERE TO LAY BACK AND DREAM OF SUMMER FUN. OF COURSE
YOU DON'T HAVE TO USE SUNSET COLOURS, BUT PINK AND YELLOW IS
MY ALL TIME FAVOURITE COLOUR COMBINATION.

THIS TECHNIQUE WOULD ALSO LOOK GOOD ON T-SHIRTS, PILLOWCASES, SCARVES...WHATEVER YOU LIKE!

YOU WILL NEED

TO DYE ONE CUSHION COVER

↓

100% WHITE COTTON CUSHION COVER (MINE IS 45 X 45CM/17¾ X 17¾IN) • ELASTIC BANDS
DYE • SALT • SPOON • JUG • RUBBER GLOVES • 2 SQUEEZY BOTTLES • BUCKET • PLASTIC BAG
SCISSORS • CUSHION PAD

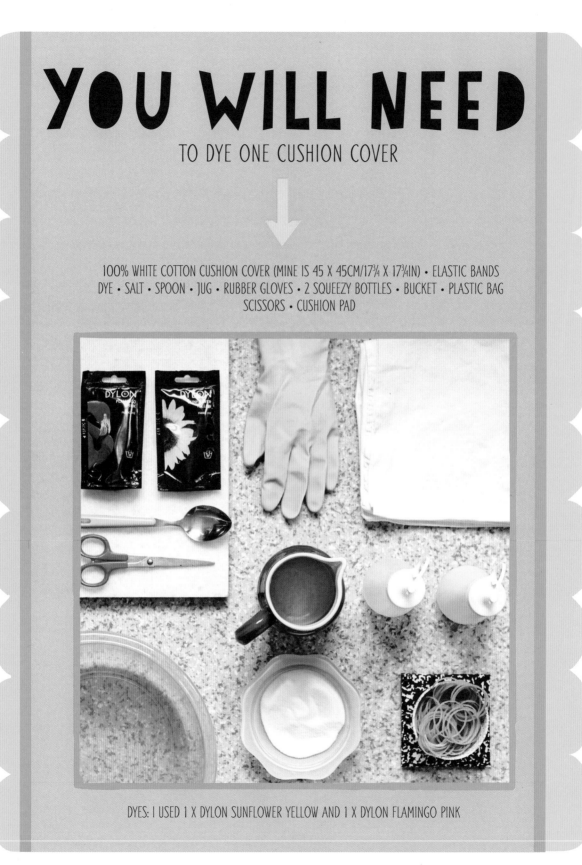

DYES: I USED 1 X DYLON SUNFLOWER YELLOW AND 1 X DYLON FLAMINGO PINK

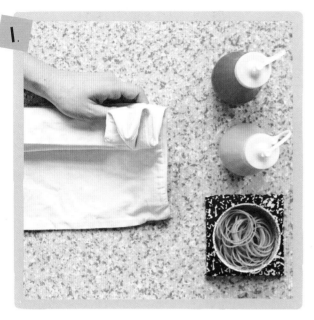

1 LAY YOUR CUSHION COVER FLAT ON A CLEAN SURFACE. START TO FOLD IT AS IF YOU ARE MAKING A PAPER FAN, FLIPPING THE CUSHION OVER AFTER EACH FOLD. THIS IS AN ACCORDION FOLD (SEE PAGE 17). MY FOLDS ARE ABOUT 4CM (1½IN) WIDE.

2 WHEN THE CUSHION COVER IS COMPLETELY FOLDED, FIND THE CENTRE OF THE CUSHION COVER BY FOLDING IT IN HALF, AND PUT AN ELASTIC BAND TIGHTLY AROUND THE MIDDLE. NOW ADD TWO MORE EVENLY SPACED ELASTIC BANDS EITHER SIDE OF THE CENTRAL ELASTIC BAND. IF YOU WANT MORE STRIPES, ADD MORE BANDS.

3 SOAK YOUR CUSHION COVER IN WATER, THEN SQUEEZE OUT THE EXCESS WATER SO THAT IT IS DAMP BUT NOT DRIPPING WET.

4 PUT ON YOUR RUBBER GLOVES AND MIX UP THE DYE FOLLOWING MY INSTRUCTIONS FOR THE SQUEEZY BOTTLE TECHNIQUE ON PAGE 16.

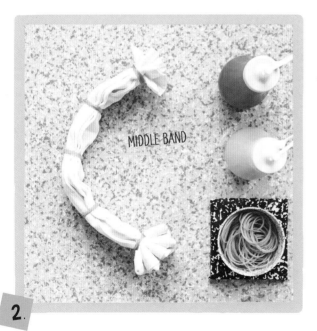

MIDDLE BAND

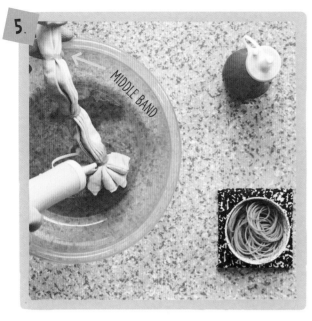

5.

MIDDLE BAND

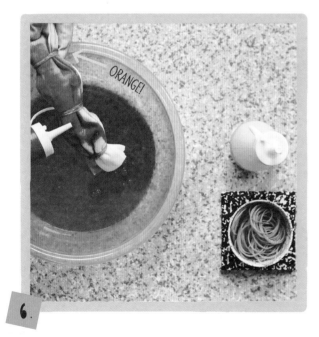

6.

ORANGE!

THROW ONTO YOUR
BED OR SOFA AND
DREAM OF A TROPICAL
PARADISE!

5 HOLD THE CUSHION COVER OVER A BUCKET. POUR THE FIRST COLOUR DYE OVER ONE HALF OF THE CUSHION COVER, OVERLAPPING THE MIDDLE ELASTIC BAND SLIGHTLY.

6 NOW REPEAT WITH THE SECOND COLOUR ON THE OTHER HALF, OVERLAPPING THE MIDDLE AGAIN TO CREATE A THIRD COLOUR. IN THIS CASE PINK + YELLOW = ORANGE.

7 LIGHTLY SQUEEZE THE CUSHION COVER AND PUT IT INTO A PLASTIC BAG. LEAVE IN THE BAG FOR ABOUT 12 HOURS, THEN RINSE UNDER COLD WATER, SNIP OFF THE ELASTIC BANDS, RINSE AGAIN AND HANG UP TO DRY. WASH THE COVER IN THE WASHING MACHINE AT 30°C, THEN INSERT A CUSHION PAD ONCE IT'S DRY.

THE DYE MAY RUN A LITTLE THE FIRST TIME YOU WASH YOUR CUSHION COVER, SO DON'T WASH IT WITH ANYTHING WHITE. AFTER THAT THE COLOURS WILL BE FIXED.

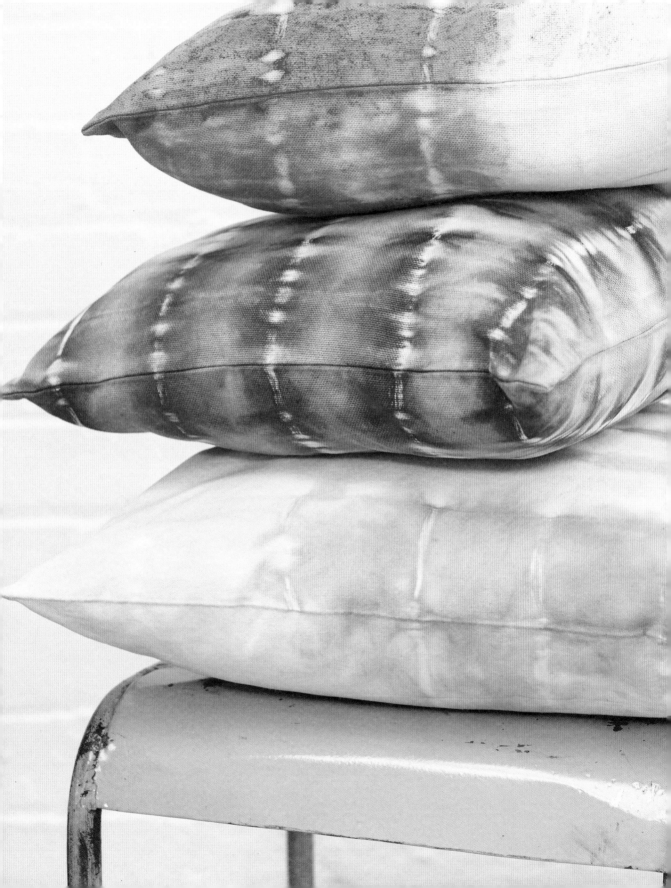

RAINBOW RAINY DAY LACES

WHENEVER I RUN TIE-DYE LACE WORKSHOPS, PEOPLE ARE QUEUING UP TO MAKE THESE! IT IS ALWAYS INTERESTING TO SEE THE DIFFERENT TECHNIQUES PEOPLE USE; SOME LEAVE A LOT OF THE LACES WHITE AND USE THE PIPETTE TO DROP TINY POLKA DOTS OF DYE ON, OTHERS GO WILD AND USE EVERY COLOUR DYE ON OFFER. THESE LACES LOOK GREAT IN A NICE WHITE PAIR OF TRAINERS AND ARE A GOOD PRESENT FOR A TRAINER-OBSESSED FRIEND.

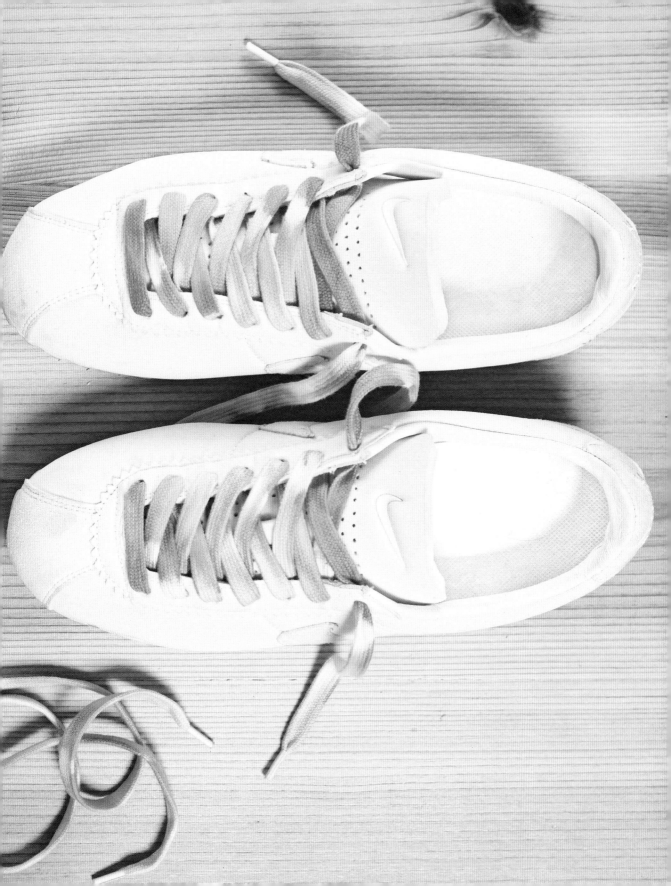

YOU WILL NEED

TO DYE ONE PAIR OF LACES

1 PAIR OF WHITE SHOE LACES (THICKER ONES FOR TRAINERS WORK BEST) • ELASTIC BANDS
RUBBER GLOVES • JUG • DYE • SALT • SPOON • 3 PIPETTES OR SQUEEZY BOTTLES • KITCHEN TOWEL
PLASTIC BAG • KNITTING NEEDLE (FOR DIP DYEING) • TONGS (FOR DIP DYEING)

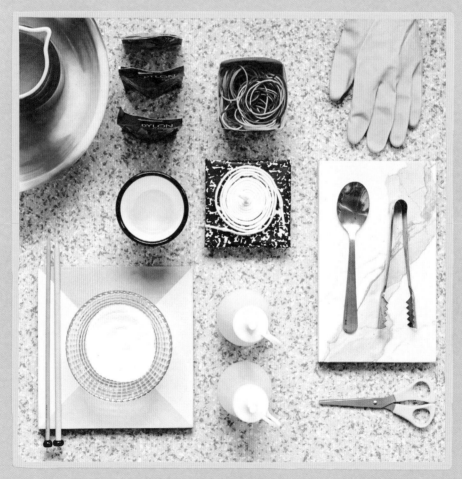

DYES: I USED 1 X DYLON FLAMINGO PINK, 1 X DYLON BAHAMA BLUE AND 1 X DYLON SUNFLOWER YELLOW

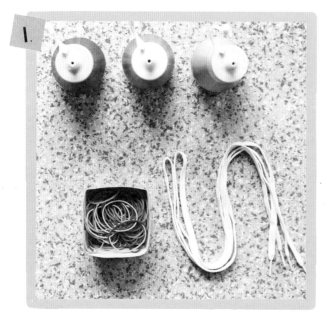

1 LAY YOUR LACES OUT ON A CLEAN FLAT SURFACE. MAKE A KIND OF SQUASHED 'S' SHAPE WITH THE LACES — LIKE A SNAKE!

2 GATHER THE S AND TIGHTLY TIE AN ELASTIC BAND ABOUT 3CM (1⅛IN) AWAY FROM THE END OF THE LACES. IF YOU WANT QUITE PROMINENT WHITE STRIPES ON YOUR LACES PUT MORE ELASTIC BANDS ON. REPEAT AT THE OTHER END.

3 SOAK YOUR LACES IN WATER, THEN SQUEEZE OUT THE EXCESS WATER SO THEY ARE DAMP BUT NOT DRIPPING WET.

4 MIX UP YOUR DYE FOLLOWING THE INSTRUCTIONS FOR MY PIPETTE TECHNIQUE ON PAGE 16.

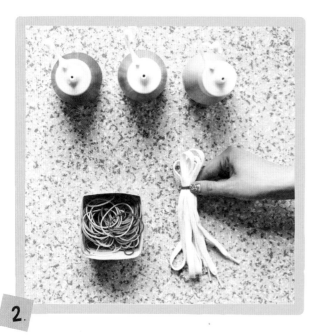

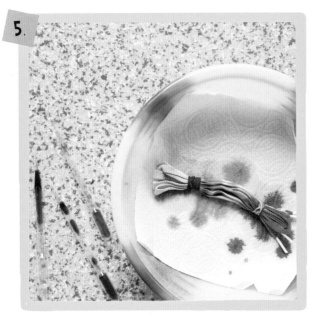

5 PLACE THE LACES ON A COUPLE OF SHEETS OF KITCHEN TOWEL. USE THE PIPETTE OR SQUEEZY BOTTLE TO GENTLY DROP SOME DYE ON THE LACES. IF YOU WANT RAINBOW LACES THEN OVERLAP THE COLOURS SLIGHTLY, REFERRING TO THE COLOUR WHEEL ON PAGE 14.

6 PUT THE LACES IN A PLASTIC BAG AND LEAVE FOR ABOUT 12 HOURS. RINSE UNDER COLD WATER, THEN TAKE THE BANDS OFF AND HANG UP TO DRY.

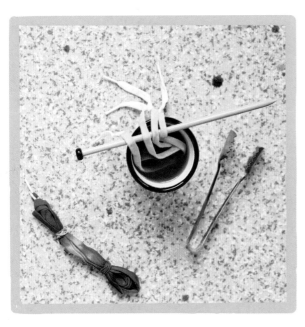

BONUS PROJECT > DIP DYE LACES

THIS IS A GOOD ONE TO TRY IF YOU JUST HAVE ONE OR TWO COLOURS OF LEFTOVER DYE.

SOAK YOUR LACES, THEN SQUEEZE OUT EXCESS WATER. USING TONGS, SLOWLY LOWER PART OF THE LACES INTO A CUP OF DYE. BALANCE THE UNDYED ENDS OVER A KNITTING NEEDLE (OR SPOON) ACROSS THE TOP OF THE CUP. LEAVE IN THE DYE FOR ABOUT 45 MINUTES, THEN RINSE AND HANG UP TO DRY.

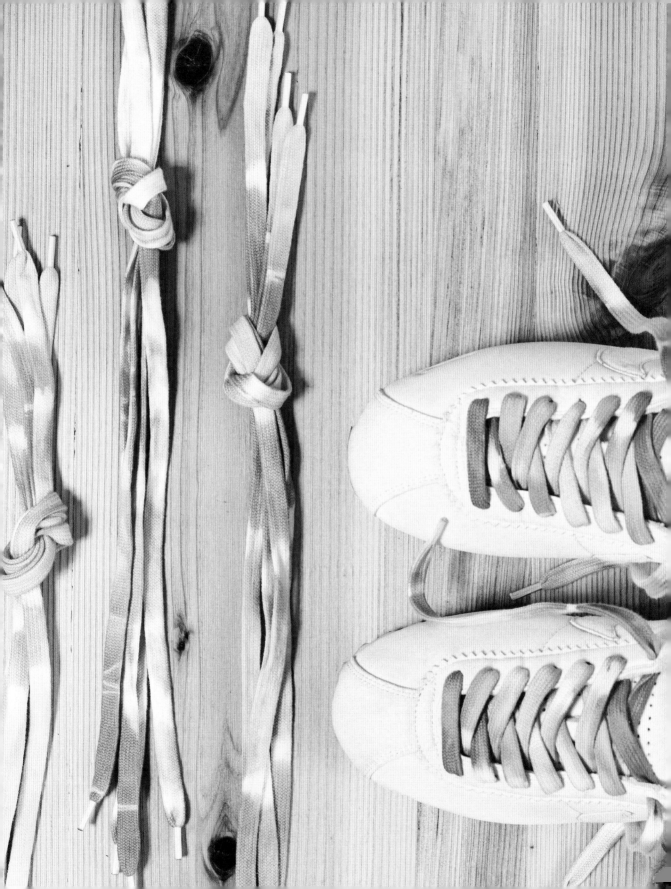

CARNIVAL SOCKS

I MAKE THESE SOCKS EVERY YEAR IN THE LEAD UP TO NOTTING HILL CARNIVAL, WHICH IS MY FAVOURITE TIME OF THE YEAR! I ONCE PUT THEM INSIDE A HUGE TROPICAL COCKTAIL PIÑATA I MADE FOR A CARNIVAL WARM-UP PARTY. WEAR THESE AND A WHISTLE AND YOU ARE READY TO GO! ASIDE FROM CARNIVAL I ALWAYS HAVE SOME BRIGHTLY DYED SOCKS IN MY STUDIO, TO GIVE TO FRIENDS AND VISITORS. I LOVE MEETING UP WITH A FRIEND AND SEEING THAT THE CARNIVAL SOCKS I GAVE THEM ARE STILL GOING STRONG! YOU CAN ALSO DYE WHITE SPORTS SOCKS, WHICH IS GREAT WHEN YOU HAVE WORN THEM SO MUCH THEY HAVE GONE GREY.

YOU WILL NEED

TO DYE THREE PAIRS OF SOCKS

↓

3 PAIRS OF WHITE 100% COTTON SOCKS • ELASTIC BANDS • RUBBER GLOVES • JUG • SPOON
DYE • SALT • 3 SQUEEZY BOTTLES • BUCKET • 3 PLASTIC BAGS

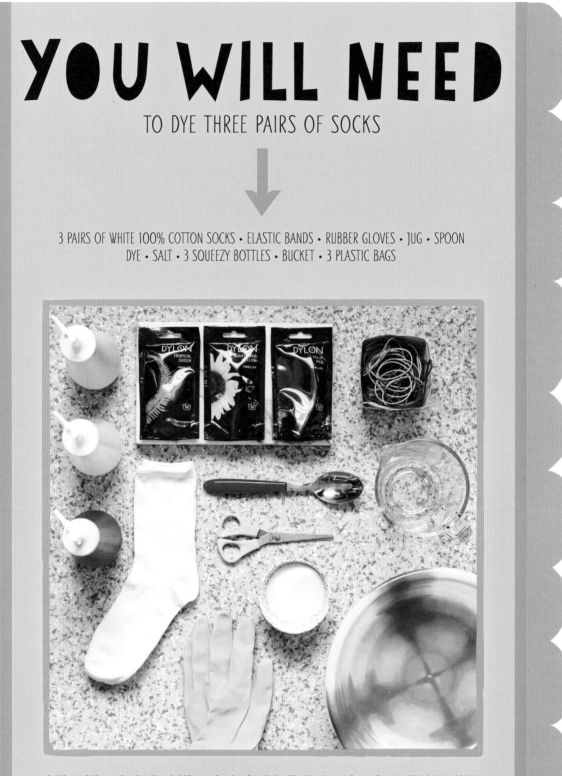

DYES: I USED 1 X DYLON TULIP RED, 1 X DYLON SUNFLOWER YELLOW AND 1 X DYLON TROPICAL GREEN

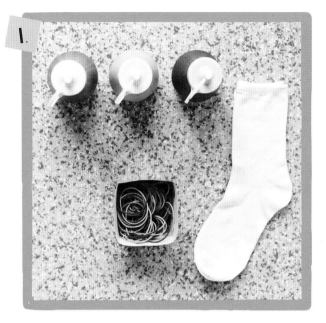

1 PLACE TWO OF YOUR SOCKS ON TOP OF EACH OTHER ON A CLEAN FLAT SURFACE. THIS IS SO THAT YOU GET A MATCHING PAIR.

2 ACCORDION FOLD YOUR SOCKS, STARTING AT THE TOP OF THE SOCK AND FOLDING ALL THE WAY DOWN TO THE TOES.

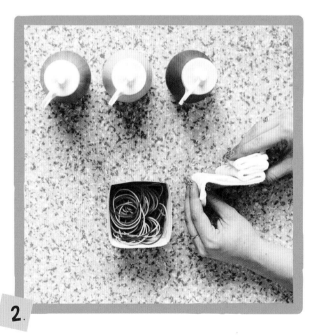

I USUALLY DYE A FEW PAIRS OF SOCKS AT ONCE – YOU CAN GET MULTIPACKS FROM MARKETS AND BIG HIGH STREET SHOPS

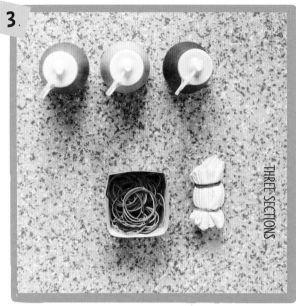

3 NOW SECURE WITH A TIGHT ELASTIC BAND ON EACH END OF THE FOLDED SOCKS. POSITION THE BANDS SO THAT THE SOCKS ARE DIVIDED INTO THREE EQUAL SECTIONS. SOAK YOUR SOCKS IN WATER, THEN SQUEEZE OUT THE EXCESS WATER SO THEY ARE DAMP BUT NOT DRIPPING WET.

4 MIX UP YOUR DYE FOLLOWING THE INSTRUCTIONS FOR MY SQUEEZY BOTTLE TECHNIQUE ON PAGE 16. POUR EACH OF THE THREE COLOURS INTO YOUR THREE SQUEEZY BOTTLES.

5 HOLD YOUR SOCKS OVER A BUCKET, TAKE THE RED DYE AND POUR GENTLY OVER ONE END SECTION OF THE SOCK. FOR THIS PROJECT YOU DON'T WANT TO OVERLAP THE DYES TO MAKE A BLENDED COLOUR. POUR THE DYE UP TO THE ELASTIC BAND.

REMEMBER THAT YOU HAVE TWO SOCKS FOLDED TOGETHER SO THE FOLDS ARE QUITE THICK. IF YOU DON'T WANT MUCH WHITE LEFT ON YOUR SOCKS, THEN POKE THE NOZZLE OF THE SQUEEZY BOTTLE INTO THE FOLDS OF THE SOCKS AND SQUIRT SOME DYE IN THERE.

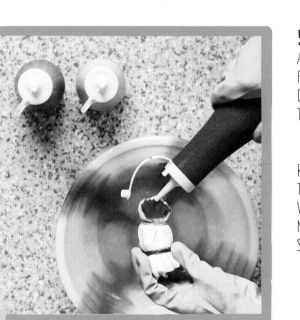

THREE SECTIONS

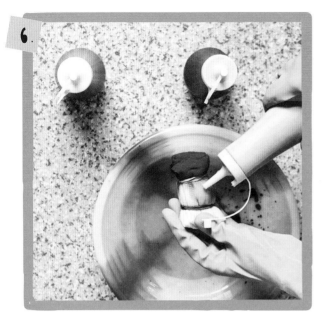

6.

6 NOW TAKE THE YELLOW DYE AND POUR IT OVER THE MIDDLE SECTION. AGAIN SQUIRT SOME DYE INTO THE FOLDS, IF YOU WANT.

7 FINALLY USE THE GREEN DYE TO DYE THE LAST SECTION OF THE SOCKS. SQUIRT SOME DYE INTO THE FOLDS OF THE SOCK, IF YOU CHOOSE TO.

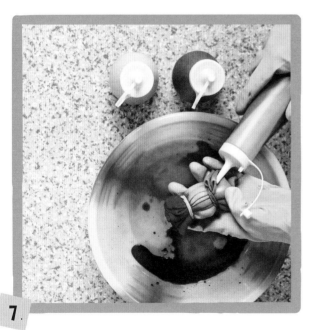

7.

8 REPEAT THE FOLDING, TYING AND DYEING PROCESS ON ALL YOUR PAIRS OF SOCKS. GIVE THE SOCKS A SQUEEZE AND PUT EACH PAIR INTO A SEPARATE PLASTIC BAG. I USUALLY WRAP THE BAG AROUND THE SOCKS THEN SECURE WITH AN ELASTIC BAND SO THAT THE DYE WON'T LEAK OUT AND SOAK INTO THE OTHER PARTS OF THE SOCK. DON'T FORGET: GREEN + YELLOW + RED = BROWN.

9 LEAVE THE SOCKS IN THE BAG FOR AT LEAST 12 HOURS. RINSE UNDER COLD WATER, THEN TAKE THE BANDS OFF AND HANG UP TO DRY. WASH IN THE WASHING MACHINE AT 30°C THEN ALLOW TO DRY.

THE DYE MAY RUN A LITTLE THE FIRST TIME YOU WASH YOUR CARNIVAL SOCKS, SO DON'T WASH THEM WITH ANYTHING WHITE. AFTER THAT THE COLOURS WILL BE FIXED AND THEY ARE READY FOR THE ROAD!

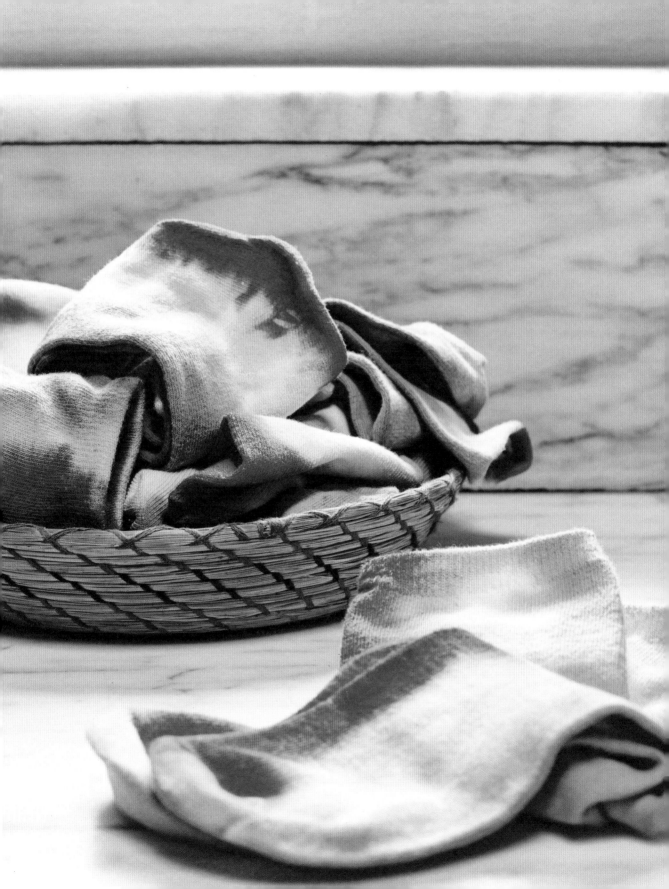

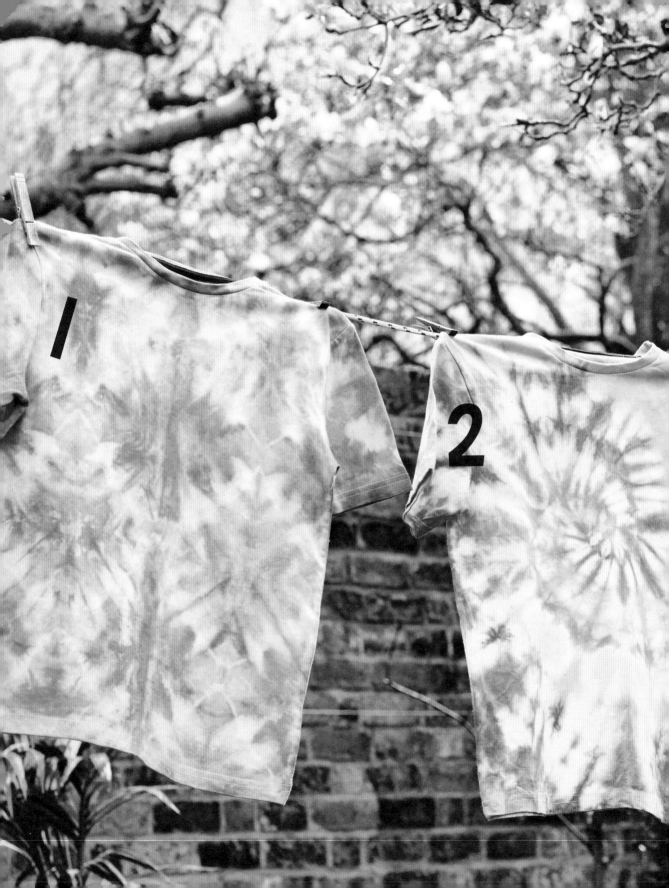

A TRIO OF T-SHIRTS

T-SHIRTS ARE A BRILLIANT THING TO EXPERIMENT WITH WHEN YOU START OUT WITH TIE-DYE. THEY ARE WHAT 90% OF PEOPLE BRING TO MY WORKSHOPS TO DYE. IT'S A GOOD IDEA TO BEGIN WITH AN OLD WHITE T-SHIRT THAT HAS SEEN BETTER DAYS. YOU CAN ALWAYS WEAR IT IN BED IF IT DOESN'T COME OUT EXACTLY AS YOU PLANNED! I LOVE DYING T-SHIRTS WITH THE KIDS I TEACH IN SCHOOL AS THEY GET SO EXCITED TO CREATE SOMETHING THEY CAN ACTUALLY WEAR. YOU CAN DO PRETTY MUCH ANYTHING ON A T-SHIRT. THERE ARE THREE TECHNIQUES HERE, BUT YOU COULD ALWAYS TRY OUT ONE OF THE OTHER IDEAS – THE BABY GRO HEART, WATERMELON BUNTING, OR ANY OF THE SHIBORI TECHNIQUES – THE POSSIBILITIES ARE ENDLESS!

YOU WILL NEED

TO DYE THREE T-SHIRTS

3 WHITE 100% COTTON WHITE T-SHIRTS • WATER SOLUBLE FABRIC PEN • SCISSORS
ELASTIC BANDS • DYE • SALT • SPOON • JUG • RUBBER GLOVES • SQUEEZY BOTTLES
3 PLASTIC BAGS • BUCKET • WIRE RACK • MARBLES

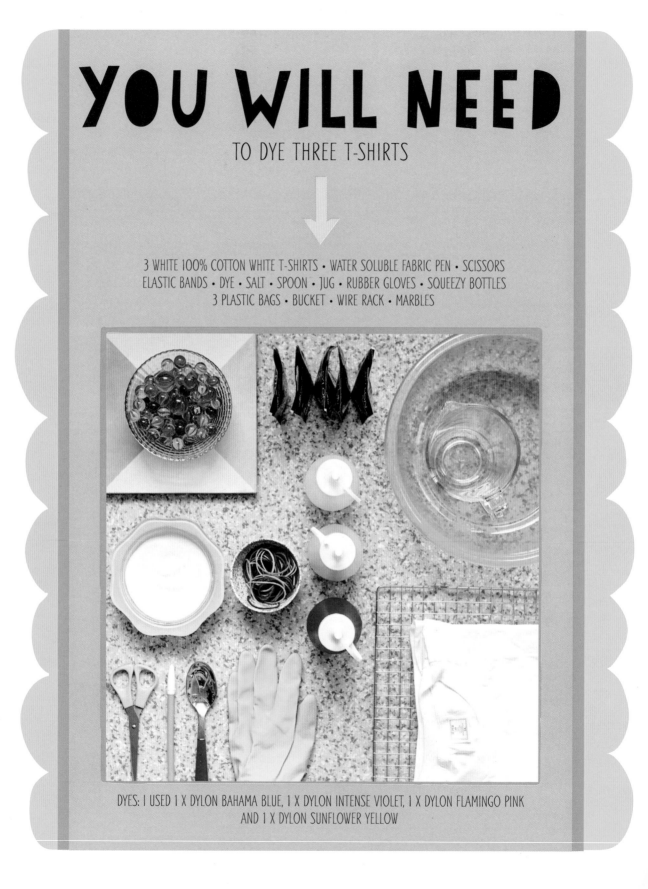

DYES: I USED 1 X DYLON BAHAMA BLUE, 1 X DYLON INTENSE VIOLET, 1 X DYLON FLAMINGO PINK
AND 1 X DYLON SUNFLOWER YELLOW

① FABULOUS FISH SCALE

1 LAY YOUR T-SHIRT FLAT ON A CLEAN SURFACE. FOLD IT IN HALF SO THAT THE SLEEVES ARE TOUCHING. NOW FOLD THE ARMPIT INTO THE CENTRE. FOLD THE SLEEVE BACK.

2 CAREFULLY FLIP THE T-SHIRT OVER AND REPEAT STEP 1. THE T-SHIRT SHOULD BE A THIN RECTANGLE WHEN YOU HAVE FINISHED.

3 TAKE YOUR FABRIC PEN AND, STARTING AT THE BOTTOM OF THE T-SHIRT, DRAW A ZIG-ZAG LINE ALL THE WAY TO THE COLLAR, GOING FROM SIDE TO SIDE. THE FABRIC PEN WILL WASH OUT, SO DON'T WORRY TOO MUCH IF YOU MAKE A MISTAKE. CUT SOME ELASTIC BANDS OPEN SO YOU CAN USE THEM AS TIES.

4 STARTING AT THE BOTTOM OF THE T-SHIRT, GATHER THE FABRIC ALONG THE FIRST LINE YOU HAVE DRAWN. TIGHTLY TIE AN ELASTIC BAND AROUND THE GATHERED FABRIC, COVERING THE LINE MADE BY THE FABRIC PEN.

5 KEEP GOING, GATHERING ALONG EACH LINE UNTIL YOU REACH THE TOP OF THE T-SHIRT. IT SHOULD NOW LOOK LIKE A SQUIGGLY SNAKE!

6 SOAK YOUR T-SHIRT, THEN SQUEEZE OUT THE EXCESS WATER SO THAT IT IS DAMP BUT NOT DRIPPING WET.

7 PUT ON YOUR RUBBER GLOVES AND MIX UP YOUR DYE FOLLOWING THE INSTRUCTIONS FOR MY SQUEEZY BOTTLE TECHNIQUE ON PAGE 16.

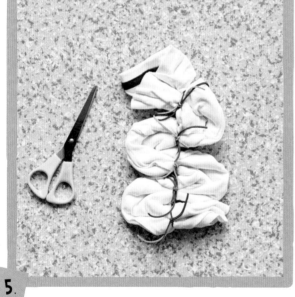

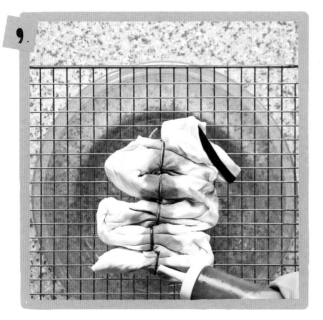

8 PUT YOUR T-SHIRT ONTO A WIRE RACK BALANCED ON TOP OF A BUCKET. LINE UP THE ELASTIC BANDS SO THAT THEY ARE IN ONE LONG LINE.

9 TAKE YOUR FIRST COLOUR OF DYE AND POUR DOWN THE MIDDLE OF THE T-SHIRT, EITHER SIDE OF THE ELASTIC BANDS.

10 NOW USE THE SAME COLOUR TO DYE EACH OUTSIDE EDGE OF THE T-SHIRT. USE YOUR SECOND COLOUR TO COVER ANY WHITE FABRIC.

11 TURN THE T-SHIRT OVER AND REPEAT STEPS 9 AND 10. GIVE THE T-SHIRT A LIGHT SQUEEZE AND PUT IT IN A PLASTIC BAG. SEE PAGE 53 FOR FINISHING INSTRUCTIONS.

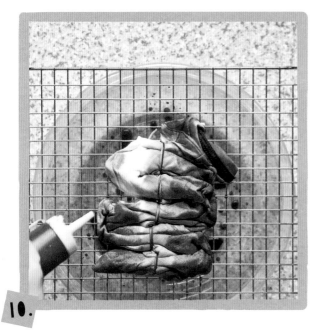

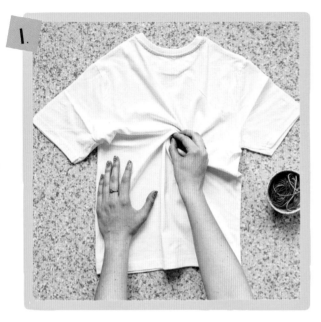

2. SWIRLY SWIRL

1 LAY YOUR T-SHIRT FLAT, FACE DOWN, ON A CLEAN SURFACE. PINCH THE T-SHIRT WITH YOUR THUMB AND FOREFINGER WHERE YOU WANT THE MIDDLE OF YOUR SWIRL TO BE. TWIST THE T-SHIRT IN A CLOCKWISE MOTION, HOLDING THE PINCHED FABRIC TIGHTLY. KEEP YOUR PINCHING HAND CLOSE TO THE TABLETOP, DON'T LIFT THE FABRIC UPWARDS TO CREATE A TENT. USE YOUR OTHER HAND TO KEEP THE T-SHIRT FLAT.

2 KEEP TWISTING THE T-SHIRT UNTIL IT RESEMBLES A DANISH PASTRY OR A SNAIL'S SHELL.

THE SWIRL DOESN'T HAVE TO BE IN THE CENTRE OF THE T-SHIRT, IT COULD BE ON A SHOULDER OR SLEEVE

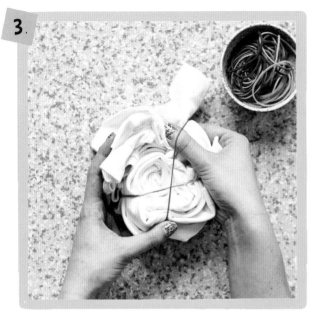

3 SLIDE SOME ELASTIC BANDS OVER THE T-SHIRT SO THAT THE SWIRL IS HELD IN PLACE. THIS CAN BE A BIT TRICKY SO YOU MIGHT WANT TO ASK SOMEONE ELSE TO HELP PUT THE BANDS ON WHILE YOU HOLD THE SWIRL TOGETHER. YOU WILL NEED TO PUT ABOUT FOUR OR FIVE BANDS ON. THEY DON'T NEED TO BE TIGHT, AS THEY ARE JUST KEEPING THE SHAPE OF THE SWIRL.

4 SOAK YOUR T-SHIRT, THEN SQUEEZE OUT THE EXCESS WATER SO THAT IT IS DAMP BUT NOT DRIPPING WET.

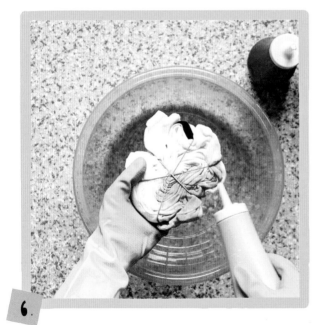

5 NOW PUT ON YOUR RUBBER GLOVES AND MIX UP YOUR DYE FOLLOWING THE INSTRUCTIONS FOR MY SQUEEZY BOTTLE TECHNIQUE ON PAGE 16. I HAVE USED THREE DYES HERE, WHICH CREATES A RAINBOW SWIRL, BUT YOU CAN JUST USE TWO DYES IF YOU PREFER A MORE SUBTLE SWIRL!

6 HOLD YOUR T-SHIRT OVER A BUCKET. IT IS IMPORTANT THAT YOU HOLD IT IN YOUR HAND RATHER THAN PUTTING IT IN THE BUCKET. IF IT IS IN THE BUCKET IT WILL SOAK UP ALL THE DYE AND THE BACK OF THE T-SHIRT WILL BE BROWN! SQUIRT YOUR FIRST COLOUR OVER ONE THIRD OF THE T-SHIRT. IMAGINE IT IS A CAKE CUT INTO THREE SLICES AND YOU WANT TO MAKE ONE SLICE YELLOW.

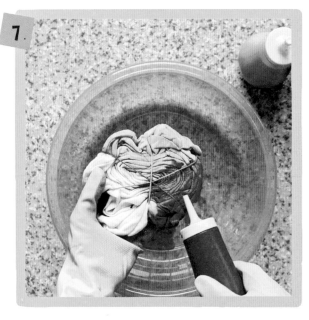

7.

THE FOLDS OF THE FABRIC WILL
REMAIN WHITE SO POKE THE NOZZLE
OF THE SQUEEZY BOTTLE INTO
THE FOLDS IF YOU WANT A MORE
COLOURFUL T-SHIRT

7 NOW COVER ANOTHER THIRD IN PINK DYE. SLIGHTLY OVERLAP THE YELLOW WITH THE PINK SO THAT YOU GET AN ORANGE SECTION WHERE THE TWO COLOURS MEET.

8 NOW USE THE BLUE DYE AND AGAIN OVERLAP THE PINK SO THAT YOU GET PURPLE AND OVERLAP THE YELLOW SO THAT YOU GET GREEN. BE CAREFUL NOT TO SQUIRT TOO MUCH DYE IN THE CENTRE OF THE SWIRL (THE THREE COLOURS TOGETHER WILL MAKE A SLUDGY BROWN).

9 TURN THE T-SHIRT OVER AND REPEAT. MAKE SURE THAT YOU MATCH THE COLOURS ON BOTH SIDES, SO THAT YELLOW IS UNDER YELLOW, PINK IS UNDER PINK AND BLUE IS UNDER BLUE – IMAGINE THAT THE DYES HAD SUNK ALL THE WAY THROUGH TO THE OTHER SIDE. GIVE THE T-SHIRT A LIGHT SQUEEZE OVER THE BUCKET AND PUT IT IN A PLASTIC BAG. SEE PAGE 53 FOR FINISHING INSTRUCTIONS.

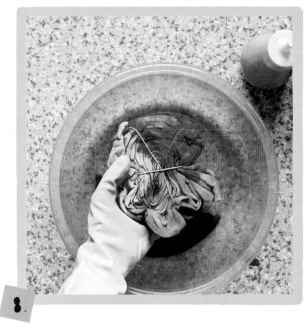

8.

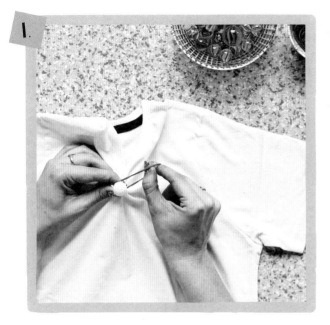

3. EASY PEASY MARBLE SCRUNCH

1 LAY YOUR T-SHIRT FLAT ON A CLEAN SURFACE. TAKE A MARBLE AND PUT IT ON THE INSIDE OF THE T-SHIRT. TIE AN ELASTIC BAND TIGHTLY AROUND THE MARBLE.

2 REPEAT SO THAT YOU GET A PATTERN. I HAVE PLACED MY MARBLES AROUND THE NECKBAND, BUT YOU COULD PLACE THEM WHEREVER YOU LIKE. EXPERIMENT WITH DIFFERENT DESIGNS!

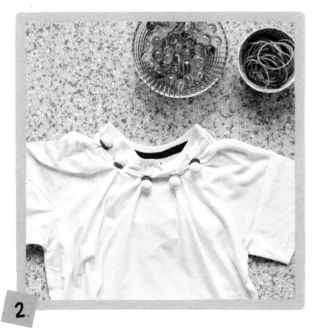

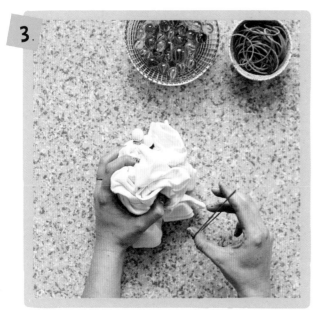

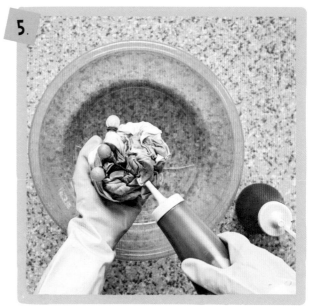

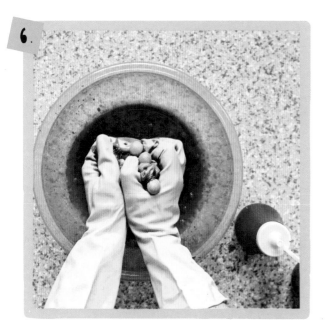

3 SCRUNCH THE T-SHIRT INTO A BALL AND SECURE WITH A FEW ELASTIC BANDS (THESE DON'T NEED TO BE TOO TIGHT). SOAK YOUR T-SHIRT, THEN SQUEEZE OUT THE EXCESS WATER SO THAT IT IS DAMP BUT NOT DRIPPING WET.

4 MIX UP YOUR DYE FOLLOWING THE INSTRUCTIONS FOR MY SQUEEZY BOTTLE TECHNIQUE ON PAGE 16.

5 HOLD THE T-SHIRT OVER A BUCKET AND SQUIRT THE FIRST COLOUR (I USED BLUE) ALL OVER YOUR T-SHIRT.

6 GIVE THE T-SHIRT A GOOD SQUEEZE WITH YOUR HANDS.

7.

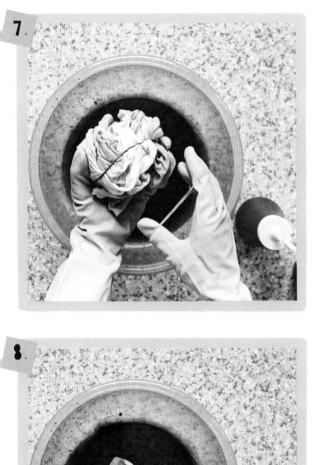

7 NOW TAKE OFF THE ELASTIC BANDS AND OPEN OUT YOUR T-SHIRT. RE-SCRUNCH THE T-SHIRT SO THAT SOME OF THE WHITE IS SHOWING ON THE OUTSIDE OF THE SCRUNCHED BALL.

8 COVER THE T-SHIRT IN YOUR SECOND COLOUR OF DYE (I USED PURPLE). GIVE THE T-SHIRT A LIGHT SQUEEZE AND PUT IT IN A PLASTIC BAG.

TO FINISH, LEAVE THE T-SHIRTS IN THE PLASTIC BAGS FOR AT LEAST 12 HOURS. RINSE UNDER COLD WATER, THEN TAKE THE BANDS OFF, REMOVE THE MARBLES AND HANG UP TO DRY. THE FIRST TIME YOU WASH THE T-SHIRTS DON'T WASH WITH ANYTHING WHITE. AFTER THAT THE COLOURS WILL BE FIXED AND THEY WILL BE READY FOR YOU TO WEAR!

'PUMP UP THE JAM!'

PUMPS

THESE PUMPS ARE A CHEAP WAY OF MAKING SOMETHING REALLY FUN
AND EYE-CATCHING. I HATE RUINING TRAINERS AT MUDDY MUSIC FESTIVALS
SO I FIND BUYING A CHEAP PAIR OF PUMPS (FROM THE 'PLIMSOLLS FOR THE
PEOPLE' MAN ON BRICK LANE) AND DYEING THEM IS A GREAT ALTERNATIVE.
YOU CAN PUT YOUR DANCING SHOES ON AND DANCE THE NIGHT AWAY,
CAREFREE! THE ADDED BONUS IS THAT YOU CAN MATCH THEM TO YOUR LOOK.
I GOT THE IDEA WHEN I MADE SOME COLOUR SPECTRUM TIE-DYE TRAINERS
FOR MY FRIEND ELLIE WHO WAS GOING TO A 30TH BIRTHDAY
PARTY AS A RAINBOW.

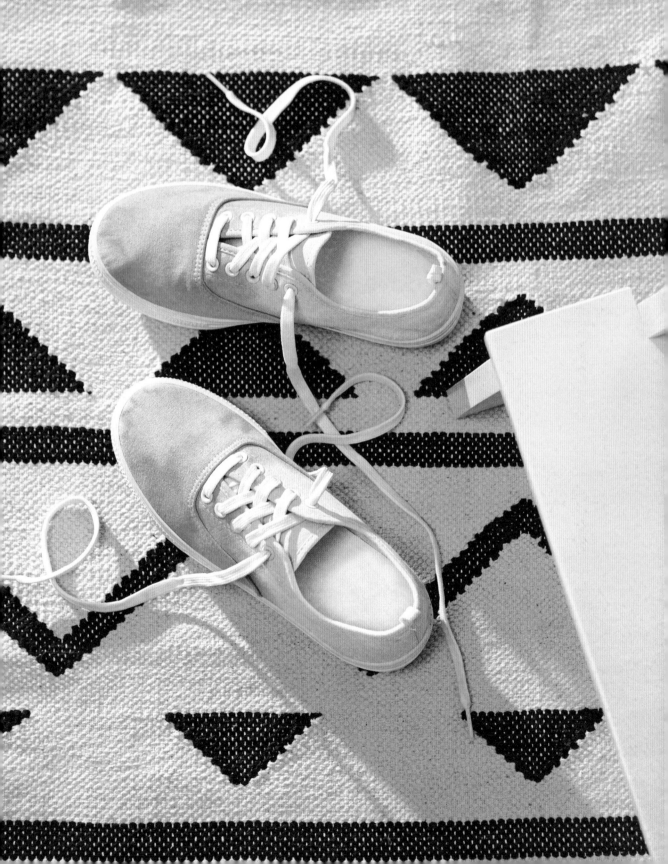

YOU WILL NEED

TO DYE ONE PAIR OF PUMPS

↓

1 PAIR OF WHITE 100% COTTON PUMPS • RUBBER GLOVES • DYE • SALT • SPOON • JUG
2 SQUEEZY BOTTLES • WIRE RACK • BUCKET • PLASTIC BAG

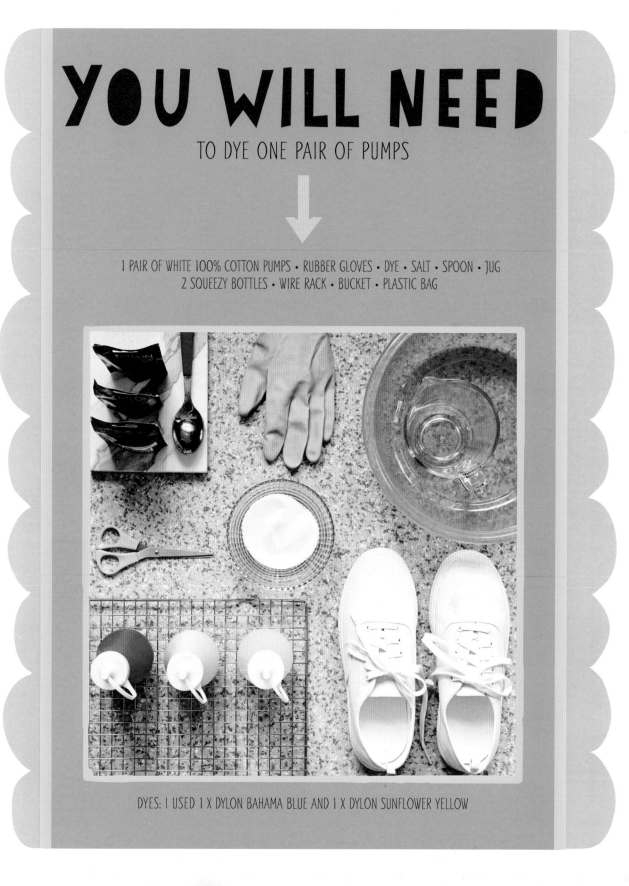

DYES: I USED 1 X DYLON BAHAMA BLUE AND 1 X DYLON SUNFLOWER YELLOW

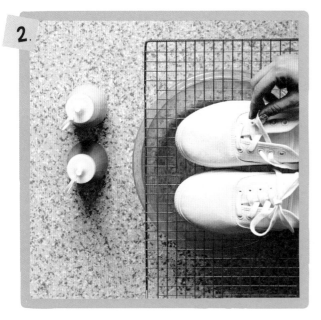

2.

I MIX UP YOUR DYE FOLLOWING THE INSTRUCTIONS FOR MY SQUEEZY BOTTLE TECHNIQUE ON PAGE 16.

2 TAKE THE LACES OUT OF THE PUMPS AND PUT TO ONE SIDE (SEE PAGE 28 FOR HOW TO DYE LACES). PUT YOUR PUMPS ONTO THE WIRE RACK BALANCED ON TOP OF THE BUCKET. SOAK YOUR PUMPS IN WATER, THEN SQUEEZE OUT THE EXCESS WATER SO THEY ARE DAMP BUT NOT DRIPPING WET.

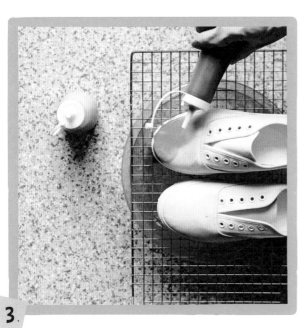

3.

3 TAKE YOUR FIRST COLOUR (I USED BLUE) AND POUR GENTLY OVER THE TOES OF THE PUMP. YOU MIGHT WANT TO PICK THE BACK OF THE PUMP UP TO TIP THE SHOE DOWNWARDS SO THAT THE DYE DOESN'T BLEED ALONG THE SOLE TOWARDS THE HEEL. COVER THE FRONT OF BOTH SHOES IN THE FIRST COLOUR.

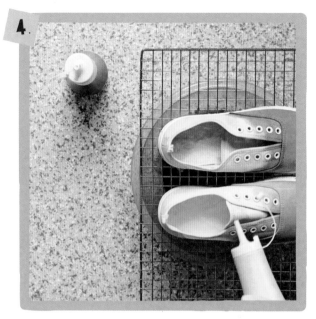

4 NOW TAKE THE SECOND COLOUR (I USED YELLOW) AND COVER ALL OF THE WHITE LEFT ON THE BACK OF THE SHOE. PICK THE FRONT OF THE PUMP UP AND TILT THE SHOE DOWNWARDS SO THAT THE DYE RUNS DOWN TOWARDS THE HEEL.

5 OVERLAP YELLOW AND BLUE TO MAKE A GREEN FADE BETWEEN THE TWO COLOURS.

6 PUT THE SHOES IN A PLASTIC BAG AND LEAVE THEM FOR AT LEAST 12 HOURS. RINSE THEM UNDER COLD WATER AND LEAVE THEM TO DRY.

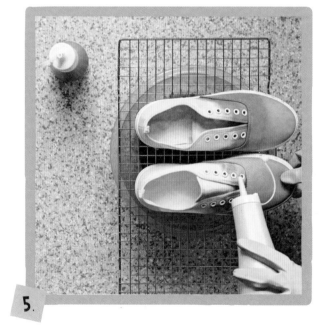

I'D RECOMMEND WEARING DARK COLOURED SOCKS THE FIRST TIME YOU WEAR THESE PUMPS JUST IN CASE THERE'S ANY DYE THAT HASN'T BEEN WASHED OUT AND SOME DYE RUBS OFF ONTO YOUR FRESH WHITE SOCKS!

6.

FRESH PRINCE SHIBORI CAP

WHEN I WAS GROWING UP I WAS OBSESSED WITH THE 90S' AMERICAN FASHION I SAW ON TV SHOWS LIKE *SAVED BY THE BELL* AND *THE FRESH PRINCE OF BEL-AIR*. TO THIS DAY IT IS STILL MY FAVOURITE ERA AND I CONSTANTLY REFER BACK TO THE PATTERNS AND COLOURS FROM THOSE SHOWS FOR INSPIRATION. THIS IS A REALLY SIMPLE PROJECT THAT IS A GREAT GIFT FOR FRIENDS. I HAVE USED NAVY FOR TWO OF THE CAPS (RIGHT), BUT YOU COULD USE A MIX OF BRIGHTER COLOURS IF YOU OR YOUR PAL HAS AN APPRECIATION OF ALL THINGS TROPICAL.

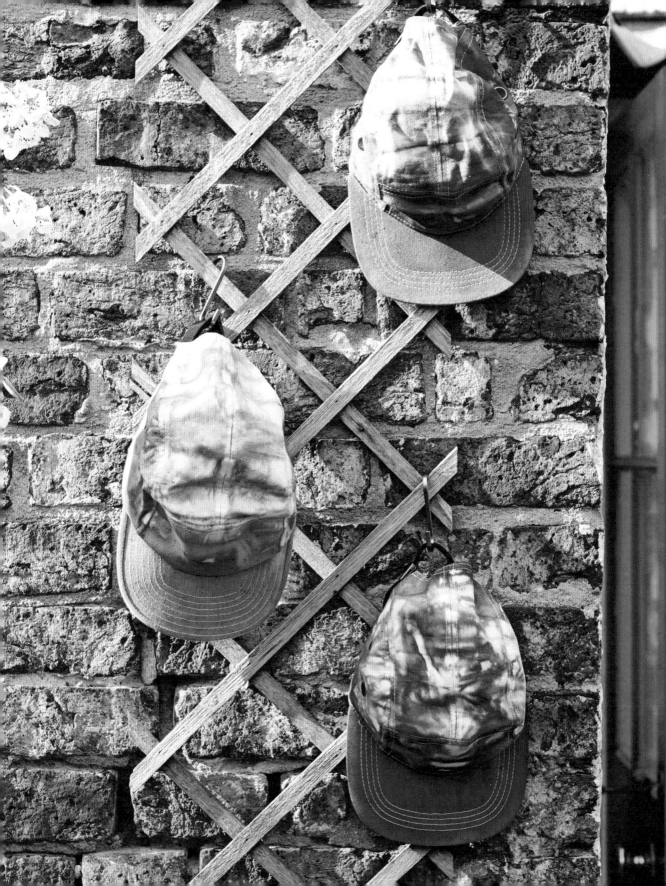

YOU WILL NEED

TO DYE ONE CAP

WHITE 100% COTTON CAP • RUBBER GLOVES • JUG • SPOON • DYE • SALT
SQUEEZY BOTTLE • 3 LARGE BULLDOG CLIPS • 2 SMALLER BULLDOG CLIPS • BUCKET • PLASTIC BAG

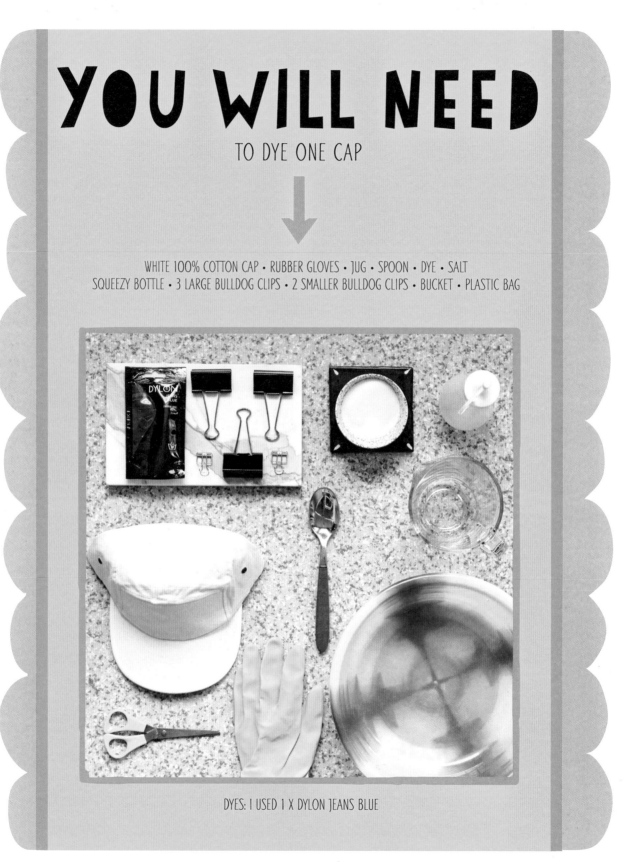

DYES: I USED 1 X DYLON JEANS BLUE

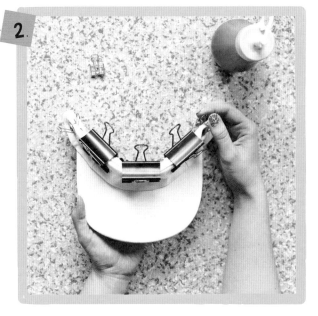

1 MIX UP YOUR DYE FOLLOWING THE INSTRUCTIONS FOR MY SQUEEZY BOTTLE TECHNIQUE ON PAGE 16.

2 HOLD THE CAP WITH THE PEAK FACING TOWARDS YOU. PINCH THE FABRIC ABOVE THE PEAK, IN THE CENTRE OF THE HAT, AND GATHER THE FABRIC IN AN ACCORDION FOLD, UNTIL YOU REACH THE BACK OF THE HAT. PUT A LARGE BULLDOG CLIP IN THE CENTRE OF THE HAT, OVER THE FOLDED FABRIC, TO TIGHTLY KEEP THE FOLDS IN PLACE. THEN PUT A SECOND LARGE BULLDOG CLIP TO THE RIGHT AND A THIRD ONE TO THE LEFT OF THE CENTRAL CLIP. THIS WILL KEEP THE FOLDS TIGHT. PUT A SMALLER CLIP ON EITHER SIDE.

3 SOAK YOUR CAP IN WATER, THEN SQUEEZE GENTLY SO THAT IT IS DAMP BUT NOT DRIPPING WET. HOLD THE HAT OVER A BUCKET AND POUR THE DYE OVER THE WHOLE THING. MAKE SURE YOU TURN IT OVER AND GIVE THE UNDERNEATH OF THE HAT A GOOD SQUIRT OF DYE.

4 GIVE THE WHOLE THING A LIGHT SQUEEZE OVER THE BUCKET AND PUT IT INTO A PLASTIC BAG. DON'T REMOVE THE CLIPS. LEAVE IT IN THE BAG FOR AT LEAST 12 HOURS. RINSE THE CAP UNDER COLD WATER, THEN TAKE THE CLIPS OFF AND HANG UP TO DRY.

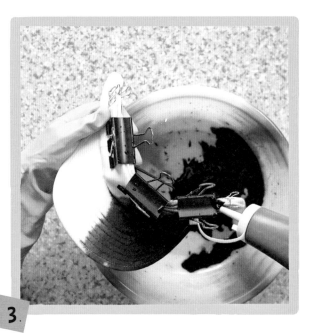

THE FIRST TIME YOU WASH THE CAP, DON'T WASH IT WITH ANYTHING WHITE. AFTER THAT THE COLOURS WILL BE FIXED AND IT'S READY FOR YOU WEAR AND FEEL AS FLY AS THE FRESH PRINCE!

'LOVE IS ALL YOU NEED'
BABY GRO

THIS IS A REALLY SWEET PROJECT THAT I GO BACK TO AGAIN AND AGAIN. BABY GROS ARE A GREAT WAY OF USING UP LEFTOVER DYE AS THEY ARE TINY AND THEY MAKE A REALLY LOVELY GIFT. IT'S NICE TO HAVE A FEW PRE-DYED READY TO SEND TO FRIENDS WHO HAVE JUST HAD A BABY! I HAVE USED TWO COLOURS IN THE 'HOW TO', BUT YOU COULD USE THREE AND MAKE A COSMIC RAINBOW HEART. GETTING THE HEART SHAPE RIGHT CAN TAKE A BIT OF PRACTICE, BUT IT'S WORTH IT!

IF YOU'RE FEELING A BIT UNSURE ABOUT WHICH COLOURS MIX WELL TOGETHER, HAVE A LOOK AT THE COLOUR WHEEL ON PAGE 14

YOU WILL NEED

TO DYE ONE BABY GRO

↓

WHITE 100% COTTON BABY GRO • WATER SOLUBLE FABRIC PEN • ELASTIC BANDS • RUBBER GLOVES
JUG • SPOON • DYE • SALT • 2 SQUEEZY BOTTLES • BUCKET • PLASTIC BAG

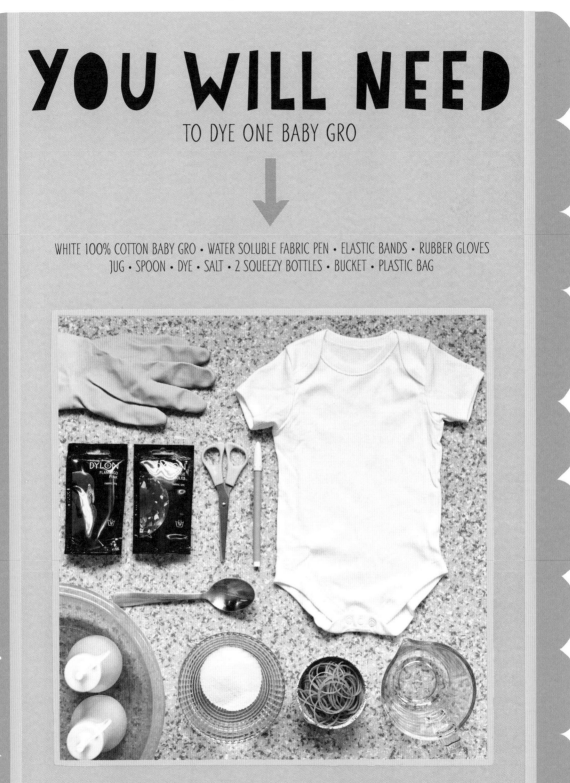

DYES: I USED 1 X DYLON FLAMINGO PINK AND 1 X DYLON INTENSE VIOLET

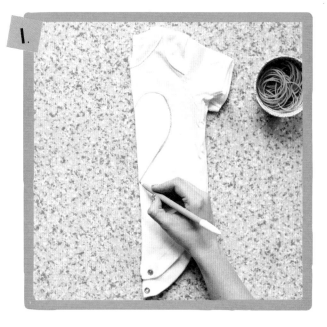

1 LAY YOUR BABY GRO FLAT, FACE DOWN, ON A CLEAN SURFACE. FOLD YOUR BABY GRO IN HALF SO THAT THE SLEEVES ARE TOUCHING. DRAW HALF A HEART SHAPE ON THE FOLD SO THAT THE CENTRE OF THE HEART BEGINS UNDER THE COLLAR AND FINISHES ON THE TUMMY. MAKE SURE YOU ARE DRAWING ON THE FRONT OF THE BABY GRO.

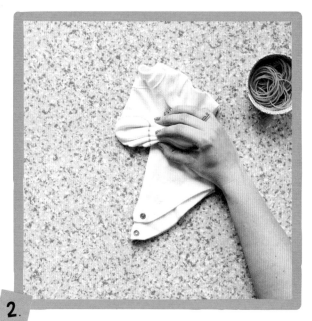

2 GATHER THE FABRIC IN AN ACCORDION FOLD ALONG THE LINE OF THE HEART. MAKE SURE THE HEART YOU DREW IS LINING UP AS YOU GO. PAY EXTRA ATTENTION TO LINING UP THE CURVED PART OF THE HEART.

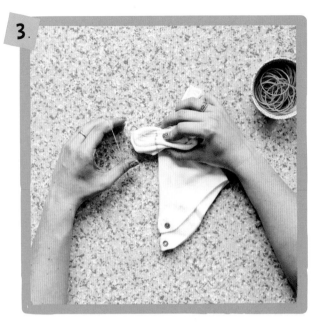

3 WHEN YOU HAVE REACHED THE END OF THE HEART, HOLD IT TOGETHER WITH ONE HAND WHILE TYING AN ELASTIC BAND OVER THE LINE WITH THE OTHER HAND. PUT MORE ELASTIC BANDS ON TOP, MAKING SURE THAT THEY ARE NICE AND TIGHT AND COVER THE LINE COMPLETELY. I USUALLY PUT ABOUT 4 ELASTIC BANDS ON.

4 ADD ANOTHER RING OF ELASTIC BANDS ABOUT 5CM (2IN) AWAY FROM THE FIRST ONES, AND THEN A THIRD RING ANOTHER 5CM (2IN) AWAY, SO THEY ARE EVENLY SPACED.

5 SOAK YOUR BABY GRO IN WATER, THEN WRING IT OUT SO THAT IT IS DAMP BUT NOT DRIPPING WET.

6 MIX UP YOUR DYE FOLLOWING THE INSTRUCTIONS FOR MY SQUEEZY BOTTLE TECHNIQUE ON PAGE 16.

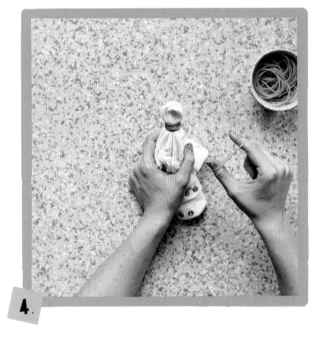

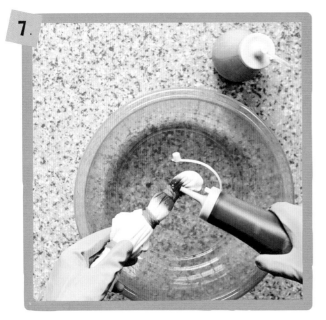

7 HOLDING THE BABY GRO OVER A BUCKET, TAKE YOUR FIRST COLOUR AND POUR IT GENTLY OVER THE FIRST GROUP OF ELASTIC BANDS (THE ONE COVERING THE HEART YOU DREW).

8 NOW TAKE YOUR SECOND COLOUR AND POUR IT OVER THE NEXT ELASTIC BAND RING. REMEMBER THAT WHERE THE TWO COLOURS START TO MIX IT WILL MAKE A THIRD COLOUR.

9 KEEP MOVING UP THE BABY GRO WITH ALTERNATING COLOURS SO YOU HAVE A STRIPEY EFFECT.

10 GIVE THE WHOLE THING A LIGHT SQUEEZE AND PUT IT INTO A PLASTIC BAG, KEEPING THE ELASTIC BANDS ON. LEAVE THE BABY GRO IN THE BAG FOR AT LEAST 12 HOURS. RINSE UNDER COLD WATER, THEN TAKE THE BANDS OFF AND HANG UP TO DRY.

THE FIRST TIME YOU WASH THE BABY GRO, DON'T WASH IT WITH ANYTHING WHITE, AFTER THAT THE COLOURS WILL BE FIXED AND IT'S READY FOR BÉBÉ TO WEAR!

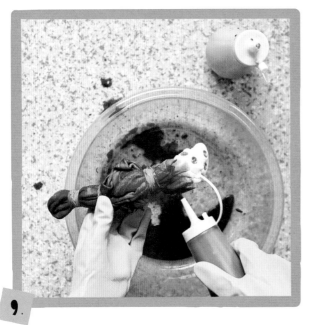

SASSY SHIBORI TEA TOWELS

THESE TEA TOWELS ARE A GREAT WAY TO EXPERIMENT WITH SHIBORI. YOU CAN BUY PLAIN WHITE TEA TOWELS ONLINE FOR NEXT TO NOTHING, ESPECIALLY IF YOU GET FACTORY SECONDS. SOMETIMES THEY MIGHT BE A BIT WONKY, BUT IT MEANS THEY ARE PERFECT FOR SOME CAREFREE SHIBORI ADVENTURES! THESE MAKE LOVELY HOUSEWARMING PRESENTS — A STACK OF THREE TIED WITH RIBBON LOOKS REALLY SMART.

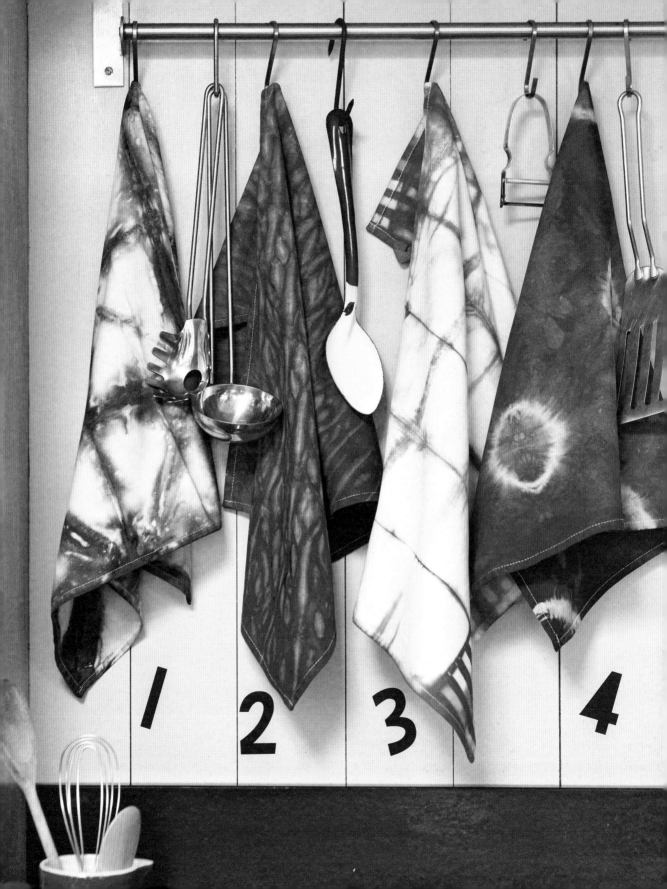

YOU WILL NEED

TO DYE A SET OF FOUR TEA TOWELS

↓

4 WHITE 100% COTTON TEA TOWELS • ELASTIC BANDS • A PVC PIPE, AROUND 4CM (1½IN) DIAMETER
STRING • 6 WOODEN LOLLY STICKS (NOT THE COLOURFUL KIND AS THEY WILL STAIN THE FABRIC)
DYE • JUG • SPOON • SALT • RUBBER GLOVES • BUCKET • SCISSORS

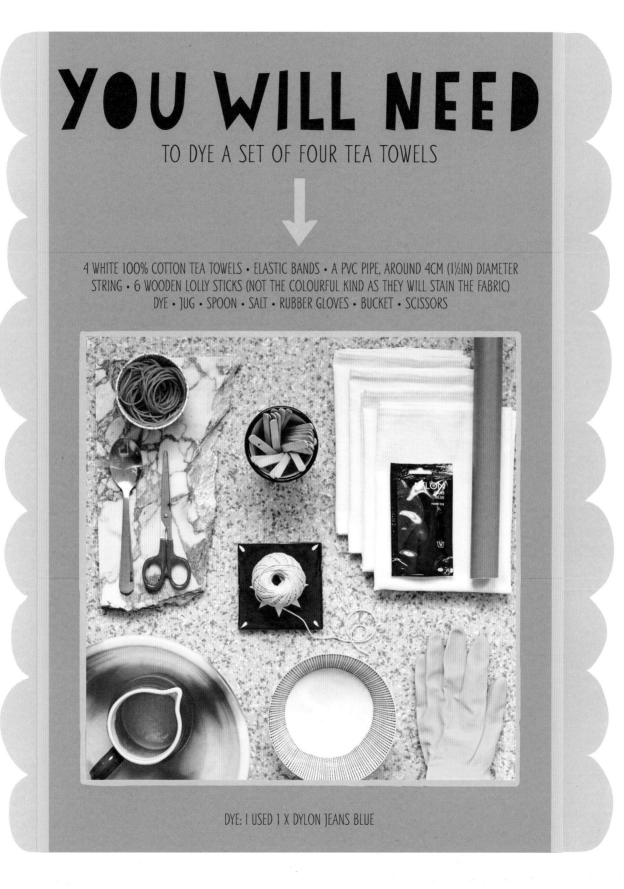

DYE: I USED 1 X DYLON JEANS BLUE

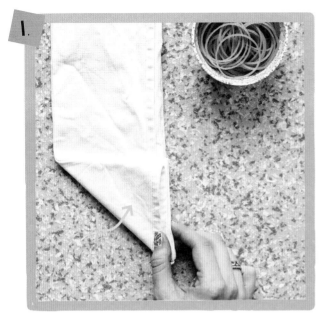

① SANDWICH

I LAY YOUR TEA TOWEL FLAT ON A CLEAN SURFACE. ACCORDION FOLD YOUR TEA TOWEL INTO FOUR, LENGTHWISE, AS IF YOU WERE MAKING A PAPER FAN (SEE PAGE 17). WHEN YOU HAVE FOLDED THE WHOLE WAY ALONG THE TEA TOWEL YOU WILL HAVE A LONG, THIN RECTANGLE SHAPE. TAKE THE BOTTOM LEFT-HAND CORNER AND FOLD IT UP AND OVER TO THE RIGHT TO CREATE A TRIANGLE.

2 PINCH THE BOTTOM RIGHT-HAND POINT OF THE TEA TOWEL AND FOLD THE TRIANGLE UNDERNEATH THE TEA TOWEL. YOU WILL NOW HAVE A RECTANGLE SHAPE AGAIN.

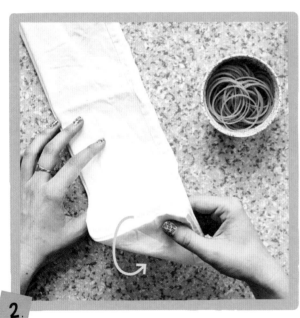

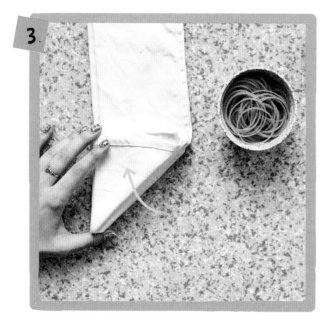

3 TAKE THE BOTTOM RIGHT-HAND POINT OF THE TEA TOWEL AND FOLD IT DIAGONALLY SO THAT YOU HAVE ANOTHER TRIANGLE SHAPE.

4 AGAIN, FOLD THE TRIANGLE UNDER THE FABRIC.

5 REPEAT UNTIL YOU HAVE COMPLETELY FOLDED THE TEA TOWEL INTO A TRIANGLE. IT SHOULD LOOK LIKE A SANDWICH. WRAP ELASTIC BANDS TIGHTLY AROUND THE TRIANGLE. SOAK IT IN WATER SO THAT IT'S DAMP BUT NOT DRIPPING WET AND PUT TO ONE SIDE READY TO DYE.

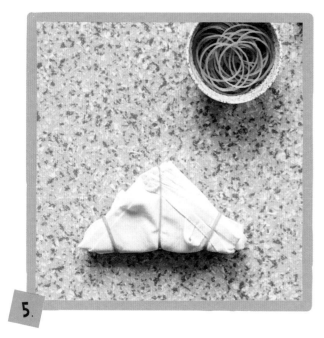

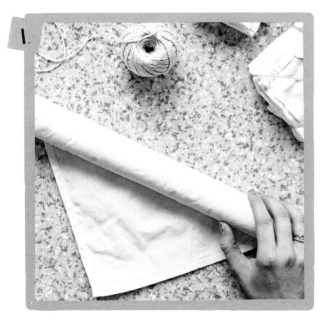

1.

2. ARASHI

1 LAY YOUR TEA TOWEL FLAT ON A CLEAN SURFACE. TAKE YOUR PVC PIPE AND PLACE IT ON TOP OF YOUR TEA TOWEL. FOLD THE BOTTOM RIGHT-HAND CORNER OVER THE PIPE, SO THAT THE TEA TOWEL IS ON A DIAGONAL. TWIST THE PIPE SO THAT THE TEA TOWEL GETS COMPLETELY WRAPPED AROUND THE PIPE.

2 TIE A PIECE OF STRING TIGHTLY AROUND THE BOTTOM OF THE PIPE AND THE TEA TOWEL. NOW WRAP THE STRING AROUND THE PIPE AND THE TEA TOWEL IN A SPIRAL, KEEPING IT TAUT BUT NOT MEGA TIGHT.

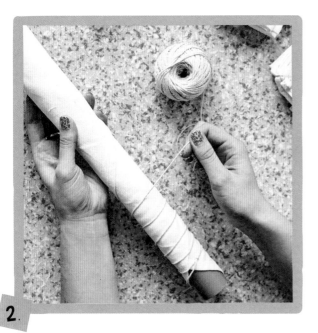

2.

'ARASHI' MEANS 'STORM' IN JAPANESE

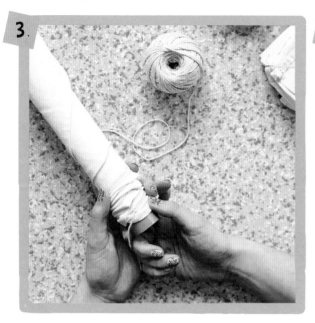

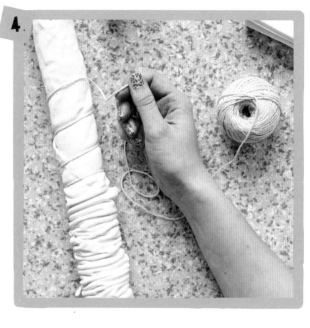

3 ONCE YOU HAVE WRAPPED THE STRING AROUND FOUR OR FIVE TIMES, SCRUNCH THE TEA TOWEL DOWNWARDS, PULLING THE STRING TIGHTLY.

4 NOW CONTINUE WRAPPING THE STRING AROUND THE PIPE AND THE TEA TOWEL, SCRUNCHING AS YOU GO.

5 WHEN THE WHOLE TEA TOWEL IS SCRUNCHED, TIE OFF THE STRING TIGHTLY. SOAK IT IN WATER SO THAT IT'S DAMP BUT NOT DRIPPING WET AND PUT TO ONE SIDE READY TO DYE.

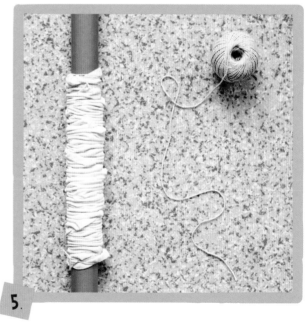

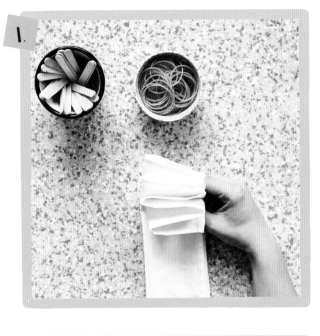

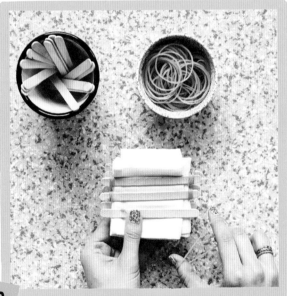

3. LOLLY STICK STRIPES

1 LAY YOUR TEA TOWEL FLAT ON A CLEAN SURFACE. ACCORDION FOLD YOUR TEA TOWEL (SEE PAGE 17). THE FOLDS SHOULD BE SLIGHTLY SMALLER IN WIDTH THAN THE LENGTH OF YOUR LOLLY STICK. LEAVE A ROUGHLY 1-CM (½-IN) GAP AT EITHER END, SO IF YOUR LOLLY STICK IS 10CM (4IN) LONG, MAKE YOUR FOLDS ABOUT 8CM (3IN) WIDE.

2 WHEN YOU HAVE FOLDED YOUR TEA TOWEL COMPLETELY IN ONE DIRECTION FOLD IT LIKE A PAPER FAN AGAIN SO THAT YOU ARE LEFT WITH A SQUARE.

3 POSITION A LOLLY STICK NEAR THE TOP OF THE SQUARE. NOW PUT ANOTHER ONE BEHIND THE SQUARE SO THAT THE TEA TOWEL IS SANDWICHED IN BETWEEN. SECURE THE TEA TOWEL IN THE MIDDLE BY WRAPPING AN ELASTIC BAND AROUND THE ENDS OF THE TWO LOLLY STICKS. REPEAT ALL THE WAY DOWN THE SQUARE, I USED THREE SETS OF LOLLY STICKS, SO SIX IN TOTAL. SOAK IT IN WATER SO THAT IT'S DAMP BUT NOT DRIPPING WET AND PUT TO ONE SIDE READY TO DYE.

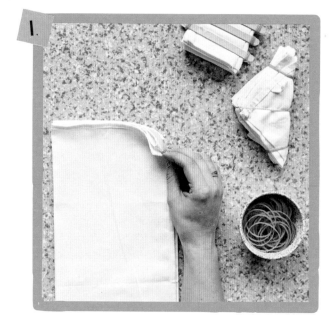

④ KUMO

1 LAY YOUR TEA TOWEL FLAT ON A CLEAN SURFACE. AS BEFORE, ACCORDION FOLD YOUR TEA TOWEL INTO FOUR, BUT THIS TIME START WITH ONE OF THE SHORT EDGES AND FOLD THE TEA TOWEL WIDTHWAYS.

2 TIGHTLY TIE AN ELASTIC BAND AROUND THE TOP RIGHT-HAND CORNER. REPEAT WITH THE BOTTOM RIGHT-HAND CORNER AND THEN TIE ANOTHER ELASTIC BAND HALFWAY DOWN THE RIGHT-HAND SIDE OF THE TEA TOWEL.

3 ON THE LEFT-HAND SIDE PINCH THE FABRIC A QUARTER OF THE WAY DOWN FROM THE THE TOP LEFT, AND TIE ANOTHER ELASTIC BAND IN PLACE. REPEAT A QUARTER OF THE WAY UP FROM THE BOTTOM LEFT-HAND CORNER.

4 GATHER THE TEA TOWEL TOGETHER AND TIE AN ELASTIC BAND AROUND THE MIDDLE. SOAK IT IN WATER SO THAT IT'S DAMP BUT NOT DRIPPING WET AND PUT TO ONE SIDE READY TO DYE.

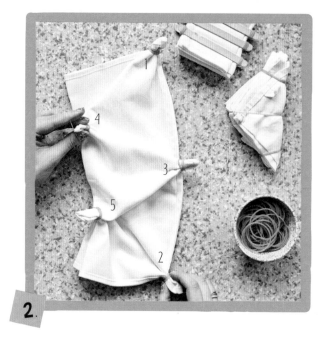

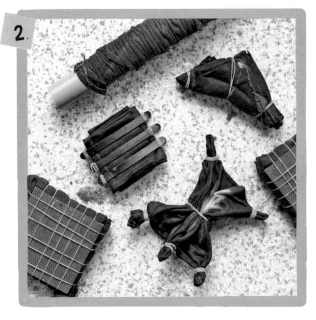

2.

READY TO DYE

1 NOW PUT ON YOUR RUBBER GLOVES AND MIX UP YOUR DYE. YOU ARE GOING TO SUBMERGE THE TEA TOWELS IN THE DYE (SEE DYE BATH, PAGE 17), SO MIX UP THE DYE ACCORDING TO THE INSTRUCTIONS ON THE BACK OF THE PACKET. POUR THE DYE INTO THE BUCKET AND LOWER IN EACH OF THE TEA TOWELS. LEAVE THEM IN THERE FOR ABOUT AN HOUR, STIRRING EVERY 10 MINUTES.

2 TAKE THE TEA TOWELS OUT AND GIVE THEM A RINSE UNDER COLD WATER. THEN TAKE ALL THE ELASTIC BANDS OFF, UNTIE THE STRING, REMOVE THE PIPE AND THE LOLLY STICKS, AND RINSE AGAIN.

3 HANG UP THE TEA TOWELS TO DRY, THEN WASH IN THE WASHING MACHINE AT 30°C. DON'T WASH THEM WITH ANYTHING WHITE THE FIRST TIME, THEN AFTER THIS FIRST WASH THE COLOUR IS SET AND THEY ARE READY TO GIVE AWAY AS PRESENTS, OR KEEP THEM FOR YOURSELF!

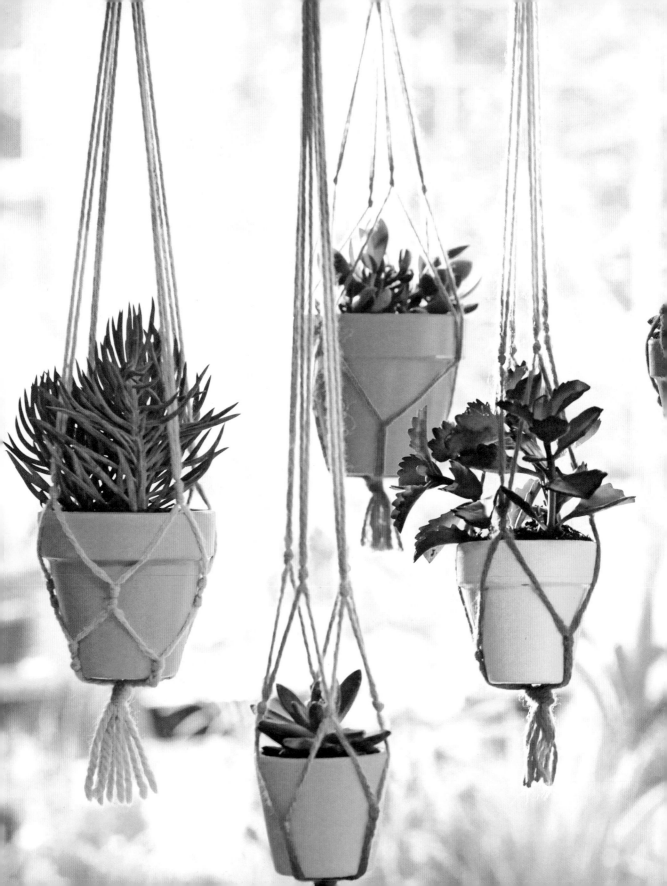

DIP DYE PLANT HANGER

THESE HANGERS ARE REALLY EASY TO MAKE – YOU JUST NEED TO GET YOUR HEAD AROUND THE STRUCTURE. AFTER YOU'VE MADE ONE AND SEEN HOW IT WORKS YOU WILL BE MAKING THEM IN MINUTES. YOU CAN MAKE THESE OUT OF ANYTHING – THICK WOOL, STRING, CORD, OR RIBBON – BUT REMEMBER, IF YOU WANT TO DYE IT THE MATERIAL NEEDS TO BE MOSTLY NATURAL FIBRES. I THINK THE HANGERS LOOK GREAT GROUPED TOGETHER, THEY WOULD MAKE EVEN THE MOST BEIGE ROOM FULL OF COLOUR AND LIFE. SUCCULENTS WORK WELL IN THE POTS AS THEY HARDLY NEED WATERING.

YOU WILL NEED

TO MAKE ONE HANGER

8M (26FT) OF WOOL/CORD/STRING • TAPE MEASURE • SCISSORS • JUG OR BUCKET • DYE SPOON • SALT RUBBER GLOVES • PLASTIC BAG

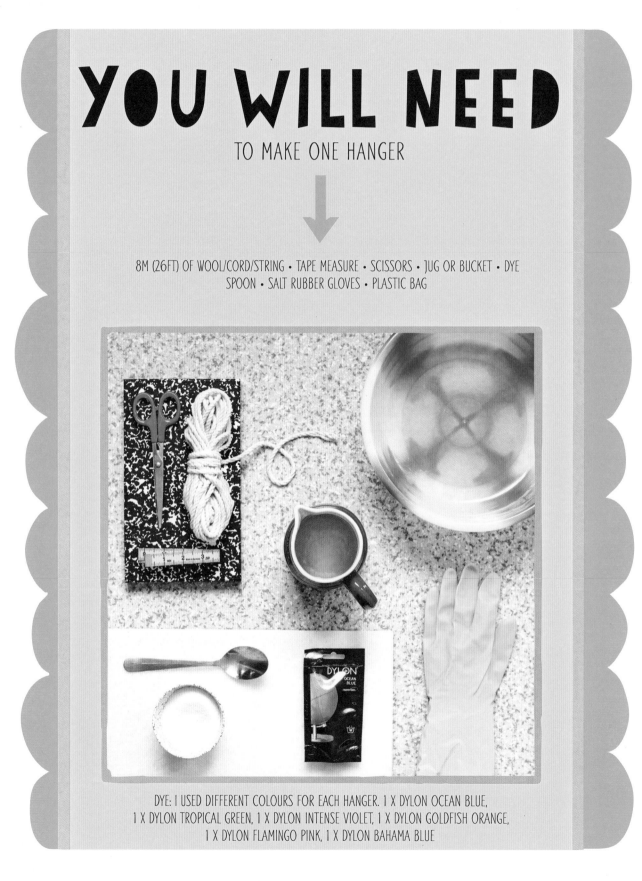

DYE: I USED DIFFERENT COLOURS FOR EACH HANGER. 1 X DYLON OCEAN BLUE, 1 X DYLON TROPICAL GREEN, 1 X DYLON INTENSE VIOLET, 1 X DYLON GOLDFISH ORANGE, 1 X DYLON FLAMINGO PINK, 1 X DYLON BAHAMA BLUE

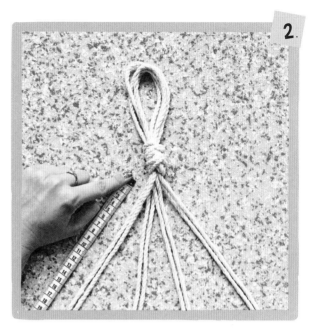

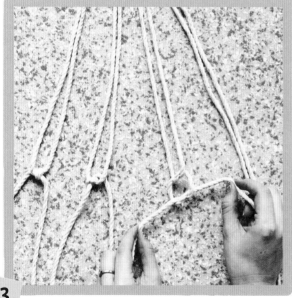

1 CUT YOUR CORD INTO FOUR 2M (6½FT) LENGTHS. HOLD ALL FOUR LENGTHS TOGETHER, FOLD THEM IN HALF, AND TIE A KNOT SO THAT YOU HAVE A HANGING LOOP.

2 PLACE YOUR KNOTTED CORDS ONTO A FLAT SURFACE. SEPARATE THE STRANDS INTO FOUR SECTIONS OF TWO, THEN TAKE YOUR FIRST SECTION AND MEASURE 30CM (12IN) DOWN FROM THE KNOT.

3 TIE A KNOT WITH THE TWO STRANDS IN THE FIRST SECTION, AND REPEAT WITH THE STRANDS IN THE THREE OTHER SECTIONS. SPREAD YOUR CORDS OUT SO THEY DON'T GET TANGLED.

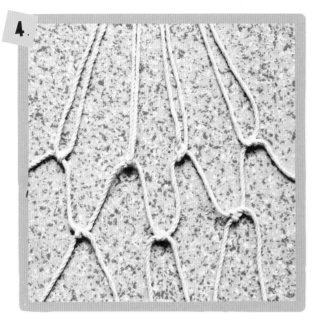

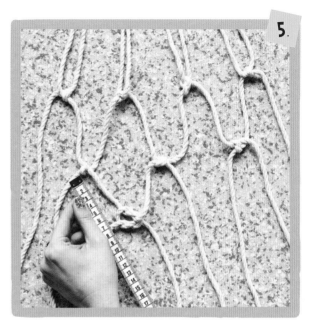

4 NOW TAKE THE LEFT STRAND OF ONE OF THE MIDDLE SECTIONS AND PAIR IT WITH THE RIGHT-HAND STRAND OF THE NEXT DOOR SECTION. TIE THESE TWO STRANDS TOGETHER 10CM (4IN) DOWN FROM THE FIRST KNOT. REPEAT WITH THE OTHER THREE SECTIONS.

5 NOW MEASURE 8CM (3IN) DOWN FROM YOUR LAST KNOT AND REPEAT STEP 4 ONCE MORE.

6 NOW GATHER TOGETHER ALL OF THE STRANDS AND TIE THEM TOGETHER, ABOUT 8CM (3IN) DOWN FROM THE LAST KNOTS YOU TIED.

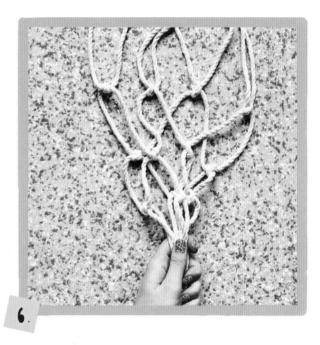

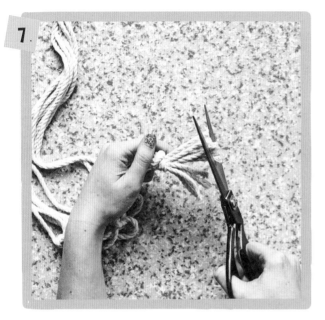

7 TRIM THE END TO MAKE A NICE EVEN TASSEL.

8 SOAK THE HANGER IN WATER, THEN SQUEEZE OUT THE EXCESS SO IT IS DAMP, BUT NOT DRIPPING WET.

9 PUT YOUR RUBBER GLOVES ON AND MIX UP THE DYE IN A JUG, FOLLOWING MY SQUEEZY BOTTLE TECHNIQUE ON P16, BUT THERE IS NO NEED TO DECANT THE DYE INTO SQUEEZY BOTTLES. SIMPLY DIP THE HANGER INTO THE JUG, TASSEL END FIRST.

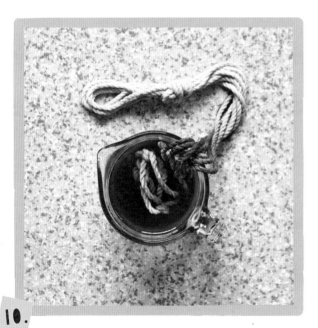

10 SLOWLY DRAW THE HANGER OUT OF THE DYE, LEAVING THE END IN FOR ABOUT 30–45 MINUTES TO CREATE A DIP DYE EFFECT.

11 YOU CAN THEN REPEAT STEPS 9 AND 10 WITH ANOTHER COLOUR WITH THE LOOPED END OF THE HANGER IF YOU WANT A THREE COLOUR EFFECT. THE THIRD COLOUR WILL BE MADE WHERE THE TWO DYES OVERLAP – SEE COLOUR WHEEL ON PAGE 14.

12 SQUEEZE OUT THE EXCESS DYE (WEARING RUBBER GLOVES!) AND PUT THE HANGER INTO A PLASTIC BAG. LEAVE IT IN THERE FOR ABOUT 12 HOURS BEFORE RINSING UNDER COLD WATER AND HANGING UP TO DRY.

YOUR PLANT POT CAN NOW BE PUT INSIDE THE HANGER AND IS READY TO FIND A HOME IN YOUR HOME.

TOTALLY TROPICAL WATERMELON BUNTING

I AM OBSESSED WITH FRUIT – PINEAPPLES, WATERMELONS OR BANANAS! I LOVE THE COLOURS, SMELL AND TASTE, SO THIS BUNTING IS ONE OF MY FAVOURITE PROJECTS IN THE BOOK! WHAT COULD BE BETTER THAN SLICES OF WATERMELON HANGING UP AROUND A PARTY? THIS TROPICAL BUNTING IS PERFECT TO HANG OUTSIDE FOR A BARBEQUE OR TO BRING THE SUMMER INSIDE ALL YEAR ROUND.

YOU WILL NEED

TO MAKE 5M (5½YDS) OF BUNTING

1 SHEET OF A3 PAPER • PENCIL • PAPER SCISSORS • 2M (2¼YDS) WHITE 100% COTTON FABRIC
IRON AND IRONING BOARD • TAPE MEASURE • PINS • WATER SOLUBLE FABRIC PEN • FABRIC SCISSORS
SEWING MACHINE • 100% COTTON THREAD • ELASTIC BANDS • WIRE RACK • BUCKET • RUBBER GLOVES
DYE • SALT • JUG • SPOON • 2 SQUEEZY BOTTLES • BLACK PERMANENT MARKER PEN
5M (5½YDS) GREEN COTTON TAPE OR BIAS BINDING (ABOUT 4CM/1½IN WIDE)

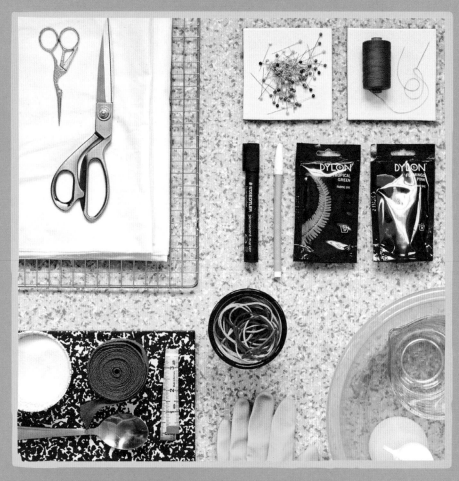

DYE: I USED 1 X DYLON FLAMINGO PINK AND 1 X DYLON TROPICAL GREEN

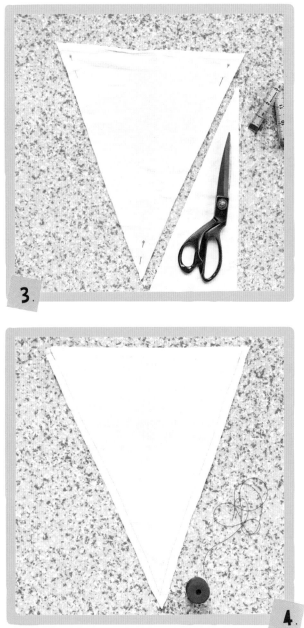

1 MAKE A PAPER TEMPLATE BY DRAWING A TRIANGLE ON THE SHEET OF PAPER AND CUTTING IT OUT. YOU CAN MAKE YOUR BUNTING TRIANGLES WHATEVER SIZE YOU LIKE, MY TRIANGLE WAS 28CM (11IN) WIDE AT THE TOP AND 31CM (12¼IN) LONG.

2 IRON YOUR FABRIC AND FOLD IT IN HALF. PIN YOUR TEMPLATE ONTO THE FABRIC, MAKING SURE YOUR PINS GO THROUGH BOTH LAYERS OF FABRIC.

3 DRAW AROUND YOUR TEMPLATE WITH THE FABRIC PEN. REMOVE THE TEMPLATE, BUT REPLACE THE PINS TO KEEP THE TWO LAYERS OF FABRIC TOGETHER. CUT OUT YOUR TWO TRIANGLES OF FABRIC. FOR 5M (5½YDS) OF BUNTING YOU WILL NEED TO CUT OUT 16 PAIRS OF TRIANGLES.

4 USE A SEWING MACHINE TO SEW AROUND BOTH OF THE LONG SIDES OF ALL OF YOUR TRIANGLES, ABOUT 1.5CM (⅝IN) FROM THE EDGE OF THE FABRIC. LEAVE THE SHORT SIDE OF THE TRIANGLES OPEN.

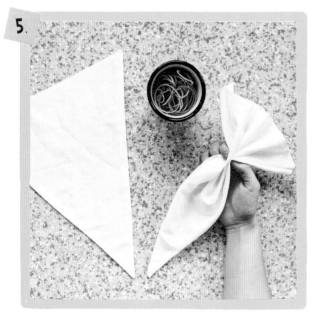

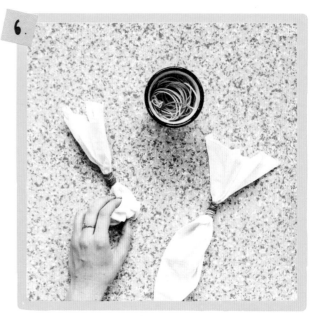

5 TURN THE TRIANGLES INSIDE OUT AND POKE THE POINT OUT WITH A PENCIL. PINCH TOGETHER THE WIDEST PART OF ONE OF THE TRIANGLES, ABOUT 6CM (2⅜YDS) DOWN FROM THE RAW EDGE OF THE FABRIC. THIS IS GOING TO BE THE WHITE PART OF THE WATERMELON, IN BETWEEN THE GREEN SKIN AND THE PINK FLESH!

6 TIE AN ELASTIC BAND TIGHTLY AROUND THE TRIANGLE. REPEAT WITH THREE MORE ELASTIC BANDS SO THAT YOU HAVE QUITE A WIDE STRIPE OF ELASTIC BANDS.

7 SCRUNCH UP THE POINTY END OF THE TRIANGLE INTO A LOOSE BALL AND PUT AN ELASTIC BAND AROUND THE FABRIC TO HOLD IT IN PLACE. REPEAT WITH ALL OF YOUR OTHER TRIANGLES. SOAK THE TRIANGLES AND SQUEEZE OUT THE EXCESS WATER SO THAT THEY ARE DAMP AND READY TO DYE.

8 PUT THE (NOW SCRUNCHED UP) TRIANGLES ONTO THE WIRE RACK, BALANCED ON TOP OF A BUCKET.

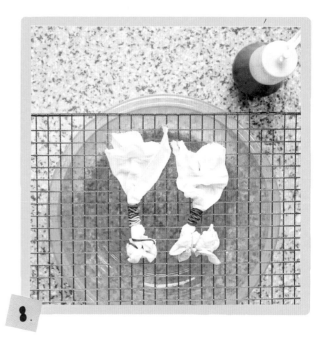

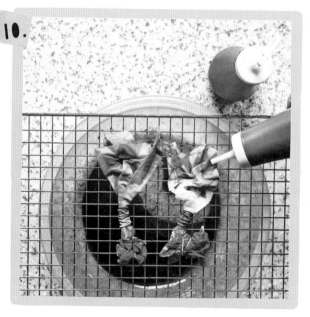

9 PUT ON YOUR RUBBER GLOVES AND MIX UP THE DYE FOLLOWING MY INSTRUCTIONS FOR THE SQUEEZY BOTTLE TECHNIQUE ON PAGE 16.

10 TAKE THE PINK DYE AND POUR GENTLY OVER THE SCRUNCHED UP PART OF THE TRIANGLE (THE POINTY END), COVERING THE FABRIC UP TO THE ELASTIC BAND IN PINK. USE THE GREEN DYE TO COVER THE TOP OF THE TRIANGLE. THEY SHOULD NOW LOOK LIKE RADISHES!

11 LEAVE YOUR TRIANGLES FOR ABOUT 12 HOURS ON THE RACK, TO ALLOW THE DYE TO SINK IN. RINSE THEM IN COLD WATER AND HANG THEM UP TO DRY.

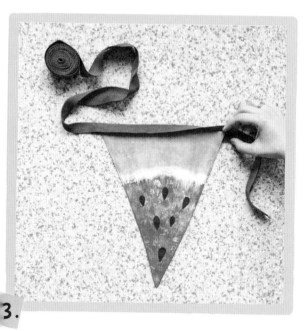

12 WHEN THE TRIANGLES ARE DRY, GIVE THEM A GOOD IRON AND THEN USE THE PERMANENT BLACK MARKER PEN TO DRAW ON SOME JUICY WATERMELON PIPS.

13 IRON YOUR COTTON TAPE OR BIAS BINDING SO THAT IT IS FOLDED IN HALF. POSITION THE TRIANGLES INSIDE THE FOLDED TAPE AT REGULAR INTERVALS AND PIN IN PLACE. SEW ALONG THE TAPE MAKING SURE THAT EACH TRIANGLE IS TRAPPED FIRMLY BETWEEN THE TWO SIDES OF THE TAPE.

HANG IN THE GARDEN/LIVING ROOM AND INVITE YOUR FRIENDS OVER FOR A TOTALLY TROPICAL TIME!

SHIBORI GRID PILLOW CASES

I LOVE THESE PILLOWCASES, EVERY TIME I MAKE THEM THEY COME OUT SLIGHTLY DIFFERENTLY. SOMETIMES THEY LOOK LIKE LITTLE SQUARES OF A NIGHT SKY. I BUY SECONDHAND PILLOWCASES AND DUVET COVERS VERY CHEAPLY FROM AN INDUSTRIAL SUPPLIES WAREHOUSE OFF BRICK LANE IN EAST LONDON. AS SOON AS A HOTEL DUVET GETS A TINY HOLE IT CAN'T BE USED ANY MORE, BUT I LOVE RECYCLING THESE LINENS FROM POSH HOTELS. OR YOU CAN JUST USE THIS TECHNIQUE TO BREATHE SOME NEW LIFE INTO YOUR OLD PILLOW CASES.

I LOVE HOW YOU CAN TRANSFORM SOME OLD GREY PILLOWCASES INTO SOMETHING COMPLETELY NEW AND EXCITING

YOU WILL NEED

TO MAKE A PAIR OF PILLOWCASES

2 WHITE 100% COTTON PILLOWCASES • 4 TILES (MINE WERE 15CM/6IN SQUARE)
ELASTIC BANDS • RUBBER GLOVES • JUG • SPOON • DYE • SALT • BUCKET

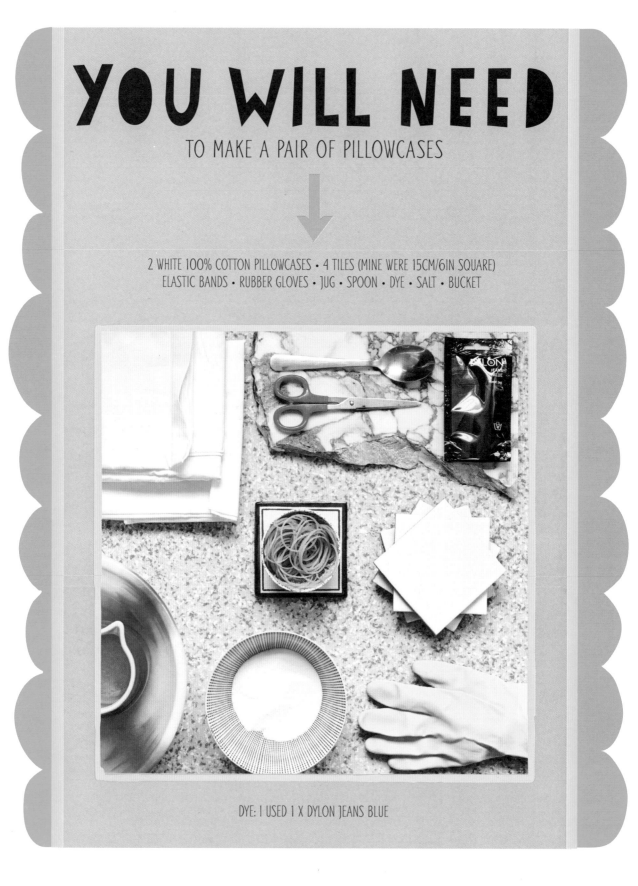

DYE: I USED 1 X DYLON JEANS BLUE

1 LAY ONE OF YOUR PILLOWCASES FLAT ON A TABLE. ACCORDION FOLD THE PILLOWCASE STARTING WITH THE SHORTEST SIDE (SEE PAGE 17). MAKE THE FOLDS ROUGHLY THE SAME WIDTH AS YOUR TILES (MINE ARE 15CM/6IN) AND FOLD THE WHOLE WAY ALONG THE PILLOWCASE.

2 NOW ACCORDION FOLD AGAIN, FOLDING THE PILLOWCASE UNTIL YOU ARE LEFT WITH A SQUARE ROUGHLY THE SAME SIZE AS ONE OF YOUR TILES.

YOU CAN USE ANY TILES FOR THIS. I USED STANDARD BATHROOM TILES FROM A HARDWARE STORE. A SQUARE PIECE OF WOOD WORKS TOO

3 TRAP THE SQUARE OF PILLOWCASE BETWEEN TWO OF THE TILES. THE GLAZED SIDE OF THE TILE SHOULD BE FACING INWARDS.

4 SECURE THE TILES IN PLACE BY PUTTING SIX ELASTIC BANDS OVER THE TILE/PILLOWCASE SANDWICH.

5 REPEAT IN THE OPPOSITE DIRECTION SO YOU HAVE A GRID MADE UP OF ELASTIC BANDS. FOLD YOUR SECOND PILLOWCASE IN THE SAME WAY AND SECURE IT BETWEEN THE OTHER TWO TILES.

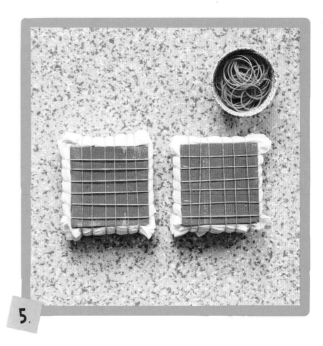

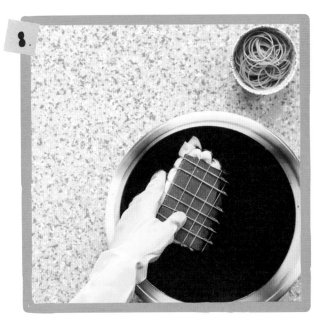

6 SOAK THE PILLOWCASES IN WATER SO THEY ARE DAMP BUT NOT DRIPPING WET.

7 NOW PUT ON YOUR RUBBER GLOVES AND MIX UP YOUR DYE. YOU ARE GOING TO SUBMERGE THE PILLOWCASES IN THE DYE (SEE DYE BATH, PAGE 17), SO MIX IT UP ACCORDING TO THE PACKET INSTRUCTIONS. IF YOU ARE MAKING THE DUVET COVER TOO (SEE PAGE 98), YOU CAN PUT THE PILLOWCASES IN WITH THE DUVET COVER SO THAT THE COLOURS MATCH, BUT YOU WILL NEED A BIGGER BUCKET!

8 POUR THE DYE INTO THE BUCKET. PLACE EACH OF THE PILLOWCASES INTO THE DYE.

9 LEAVE THE PILLOWCASES IN THE DYE FOR ABOUT AN HOUR, STIRRING EVERY 10 MINUTES OR SO. RINSE UNDER COLD WATER WHILE THE PILLOWCASES ARE STILL IN THE TILE SANDWICH, THEN TAKE THE BANDS OFF. RINSE AGAIN AND HANG UP TO DRY. THE FIRST TIME YOU WASH THE PILLOWCASES DON'T MIX THEM WITH ANYTHING WHITE. AFTER THAT THE COLOURS WILL BE FIXED AND THEY ARE READY FOR YOU TO PUT ON YOUR PILLOWS AND DREAM OF SHIBORI.

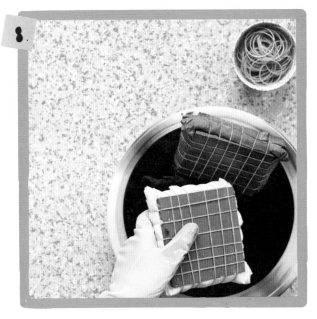

IF YOU MAKE THESE AT THE SAME TIME AS THE DUVET COVER (SEE PAGE 98) YOU CAN PUT THEM IN THE SAME DYE BATH

SHIBORI WIGGLE WAVE DUVET COVER

ONCE YOU HAVE CREATED THIS DUVET COVER YOU WILL WANT TO SHIBORI EVERYTHING YOU OWN! THIS PROJECT COMBINES THREE DIFFERENT SHIBORI TECHNIQUES. MAKE SURE YOU HAVE A LARGE CLEAR SPACE TO WORK IN. TAKE YOUR TIME AND I PROMISE IT WILL BE WORTH IT WHEN YOU OPEN IT UP AT THE END! I LOVE HOW USING A NEEDLE AND THREAD CAN CREATE SUCH INTERESTING SHAPES AND PATTERNS. TRADITIONALLY SHIBORI IS DONE WITH BLUE DYE, BUT YOU COULD USE ANY COLOUR YOU LIKE TO MATCH YOUR COLOUR SCHEME.

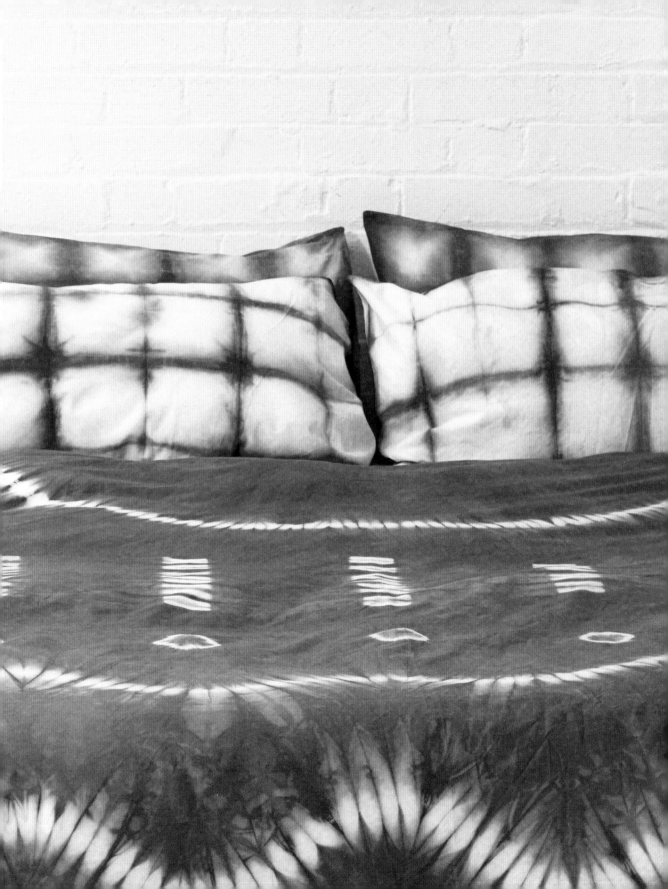

YOU WILL NEED

TO DYE ONE DOUBLE DUVET COVER

↓

WHITE 100% COTTON DOUBLE DUVET COVER • WATER SOLUBLE FABRIC PEN • 7 LARGE BULLDOG
CLIPS ELASTIC BANDS • NEEDLE AND STRONG THREAD • RUBBER GLOVES • JUG • SPOON • DYE
• SALT LARGE BUCKET • SCISSORS

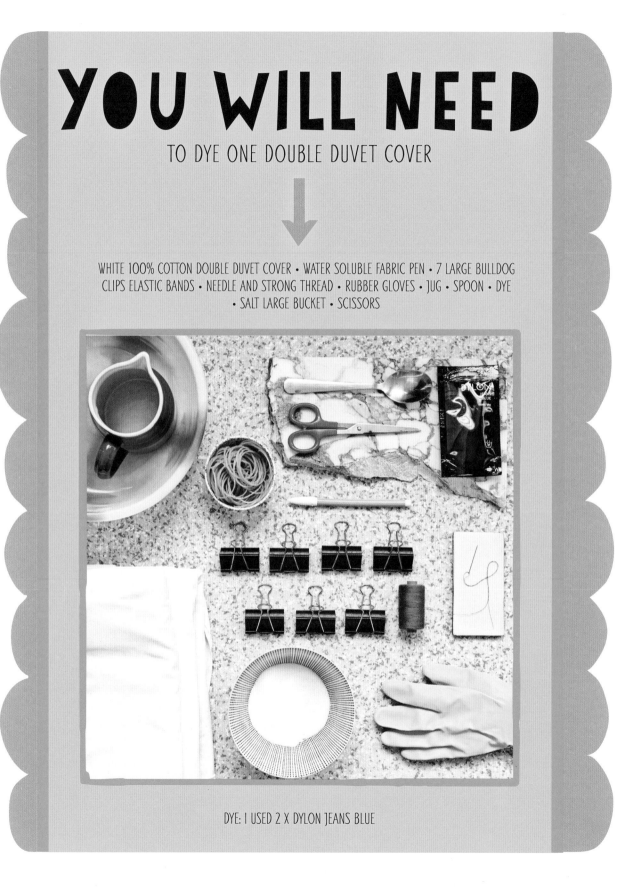

DYE: I USED 2 X DYLON JEANS BLUE

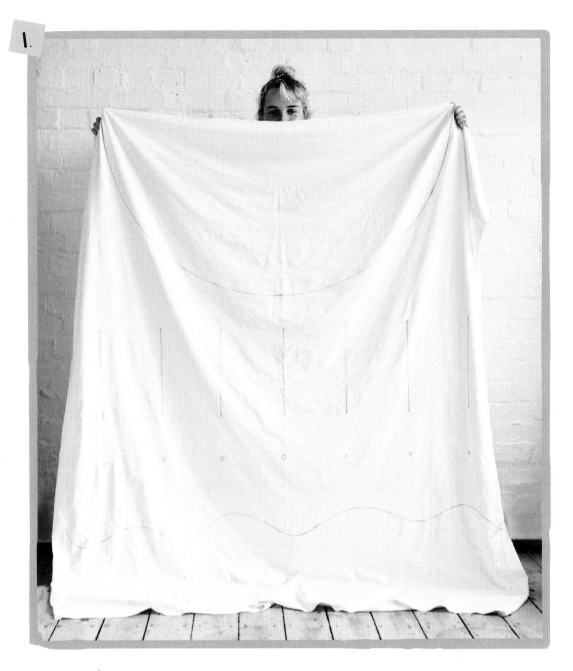

I USING THE FABRIC PEN, DRAW OUT YOUR DESIGN ONTO THE DUVET COVER.
YOU MIGHT FIND IT EASIEST TO DO THIS ON THE FLOOR. I DREW A SEMI-CIRCLE
AT THE TOP OF THE DUVET COVER, SEVEN 30CM (12IN) VERTICAL LINES, SOME
DOTS UNDERNEATH THE LINES AND THEN TWO WIGGLY LINES. I LIKE TO THINK THAT
THE WIGGLES COULD BE THE SEA AND THE SEMI-CIRCLE THE SUNRISE/SUNSET!

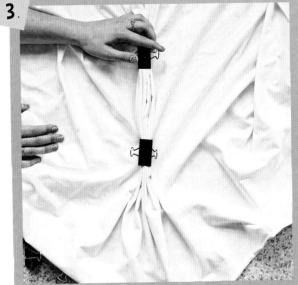

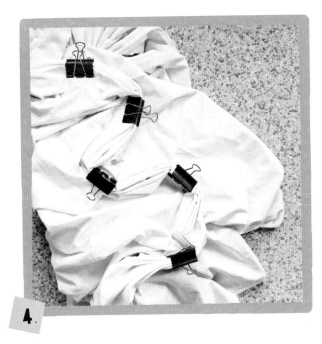

2 GATHER THE FABRIC WITH YOUR FINGERS ALONG THE STRAIGHT LINES. THE GATHERS SHOULD BE ABOUT 2CM (¾IN); MAKE SURE YOU ARE GATHERING BOTH SIDES OF THE DUVET COVER AT ONCE AND ACCORDION FOLD THE FABRIC SO THAT YOU CAN SEE THE STRAIGHT LINE MATCHING UP ACROSS THE FOLDS.

3 WHEN YOU GET TO THE END OF THE LINE, HOLD THE FOLDS IN ONE HAND AND SECURE THEM IN PLACE WITH A BULLDOG CLIP.

4 REPEAT STEPS 2 AND 3 WITH THE OTHER SIX LINES.

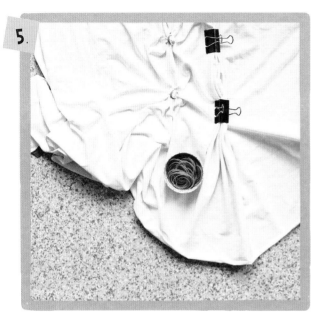

5 NOW PINCH THE DOTS YOU DREW UNDERNEATH THE VERTICAL LINES. MAKE SURE YOU ARE PINCHING BOTH SIDES OF THE DUVET COVER AT ONCE. TIGHTLY TIE AN ELASTIC BAND AROUND THE FABRIC, ABOUT 3CM (1¼IN) DOWN FROM THE TIP OF THE POINT WHERE THE DOT IS. REPEAT WITH THE OTHER SIX DOTS.

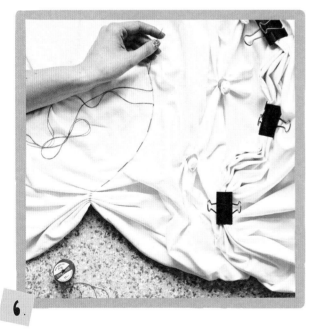

6 ONCE YOU HAVE DONE ALL THE PINCHING AND FOLDING, IT IS TIME TO START SEWING (I ALWAYS LEAVE THE SEWING UNTIL LAST AS IT REALLY RUCHES THE FABRIC, MAKING IT HARD TO THEN DO THE FOLDING). DOUBLE UP YOUR THREAD AND TIE A KNOT IN THE END. START AT THE END OF ONE OF THE WIGGLY LINES. SEW ALONG THE LINE USING A RUNNING STITCH. EACH STITCH SHOULD BE ABOUT 2CM (¾IN) LONG. DON'T WORRY TOO MUCH ABOUT MAKING EACH STITCH THE EXACT SAME LENGTH – ROUGHLY THE SAME LENGTH WILL DO!

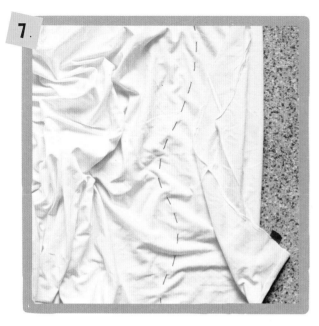

7 GATHER THE FABRIC GENTLY AS YOU GO. REPEAT WITH THE OTHER WIGGLY LINE.

8 ONCE YOU HAVE SEWN THE LENGTH OF THE TWO WIGGLY LINES, GATHER THE FABRIC UP TIGHTLY. THIS WILL CREATE LOTS OF LITTLE PLEATS. THE FABRIC NEEDS TO BE GATHERED AS TIGHTLY AS YOU CAN. ONCE YOU HAVE PULLED THE THREAD TAUT, TIE A KNOT. YOU CAN ALSO DO A FEW EXTRA STITCHES TO REINFORCE THE KNOT. YOU CAN ALSO USE A CUT OPEN ELASTIC BAND TO TIE AROUND THE SEWN LINE TO REINFORCE THE THREAD.

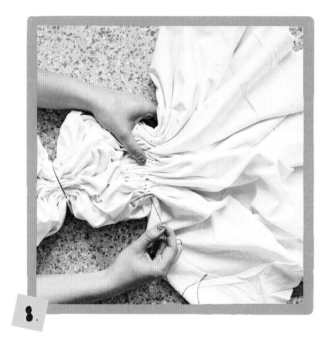

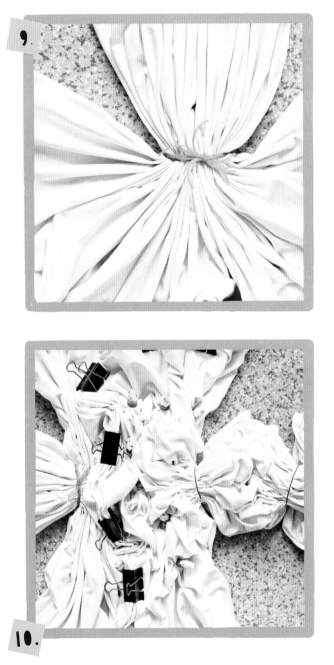

9 REPEAT STEPS 6–8 FOR THE SEMI-CIRCLE.

10 SOAK YOUR DUVET COVER IN WATER, THEN WRING IT OUT SO THAT IT IS DAMP BUT NOT DRIPPING WET.

11 NOW PUT ON YOUR RUBBER GLOVES AND MIX UP YOUR DYE. OU ARE GOING TO SUBMERGE THE FABRIC IN THE DYE (SEE DYE BATH, PAGE 17), SO MIX IT UP ACCORDING TO THE PACKET INSTRUCTIONS. YOU WILL NEED TWO PACKETS OF DYE FOR A DOUBLE DUVET TO GET A REALLY INTENSE BLUE, BECAUSE THERE IS SO MUCH FABRIC.

12.

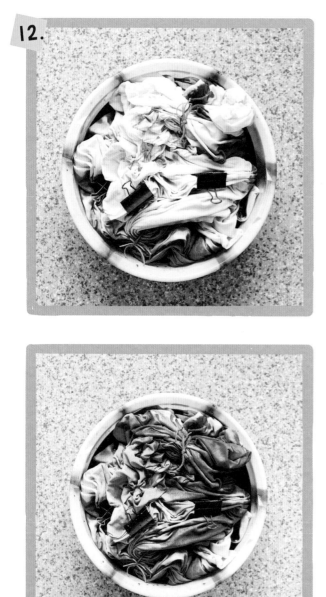

13.

12 POUR THE DYE INTO THE BUCKET. PLACE THE DUVET COVER IN THE DYE. IDEALLY YOU NEED A BUCKET BIG ENOUGH SO THAT THE DUVET COVER HAS SOME ROOM TO MOVE AROUND.

13 LEAVE THE DUVET COVER IN FOR ABOUT AN HOUR, STIRRING EVERY 10 MINUTES OR SO TO MAKE SURE ALL OF THE FABRIC COMES INTO CONTACT WITH THE DYE. IF YOU ARE ALSO DYEING PILLOWCASES, PUT THEM IN AT THE SAME TIME SO THAT THE COLOUR MATCHES THE DUVET.

14 RINSE UNDER COLD WATER, THEN TAKE THE BANDS OFF; UNCLIP THE BULLDOG CLIPS AND CAREFULLY CUT AND REMOVE THE RUNNING STITCH THREADS. RINSE AGAIN AND HANG UP TO DRY. THE FIRST TIME YOU WASH THE DUVET COVER, DON'T WASH IT WITH ANYTHING WHITE, AFTER THAT THE COLOURS WILL BE FIXED, AND IT'S READY FOR YOU TO PUT ON YOUR BED AND DREAM OF WAVES ON A BEACH.

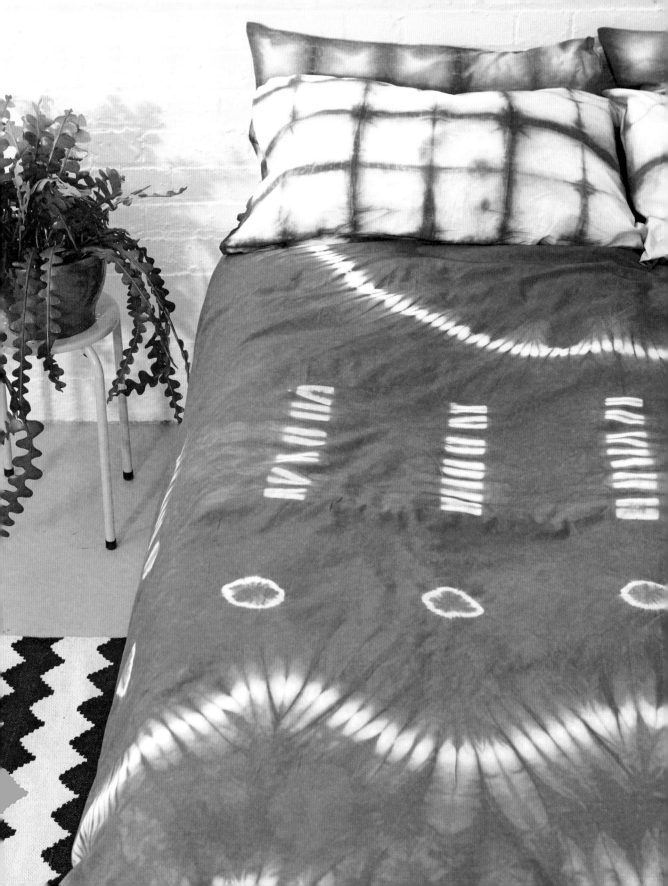

ABOUT ME

I have always struggled with giving myself a job title. I am a prop maker, artist, tie-dye enthusiast… but really I just love making things! From a young age I have been happiest when getting messy with paints or drawing. It runs in my family – both my mum and grandma are very creative. When I was desperate for baggy trousers aged 10, my mum quickly ran me up a pair on her sewing machine, with a matching scrunchie! I love working out how to make something myself.

After graduating from Brighton University in 2010 with a degree in Fine Art Sculpture, I knew I wanted to do something creative and was desperate to find any way not to work in an office! I gained valuable experience doing many odd jobs and assistant roles. I assisted set designer Anna Lomax for two years, making anything from knitted telephones to giant gold inflatables. Now my week can include anything from teaching art workshops in local primary schools, making cardboard props and piñatas, doing massive drawings on windows, or tie-dyeing 400 T-shirts. All of my work has a playful edge to it, often featuring giant glittery palm trees and golden pineapples. I still look to my favourite 90s' TV shows for inspiration – *Saved by the Bell* and *The Fresh Prince of Bel-Air*.

I run 'Get Rich or Tie-Dyeing' workshops all over London, where you can learn for yourself how to transform your T-shirts, and I have delivered workshops for Nike, Lazy Oaf, Vans, Shoreditch House, Liberty and Vice.

Take a look at my website www.lizzie-king.com to see more of my work.

Share your own tie-dye projects online – I'd love to see them!
@lizzie_kingdom #Tie&Dye

SUPPLIERS

Dylon dyes are available from supermarkets and hardware stores, as well as haberdasheries and online. www.dylon.co.uk

Markets are brilliant for finding socks and white T-shirts: I love Ridley Road in London – there's a T-shirt stand where they have every colour you can imagine for £1 each!

Pound shops are my favourite places anyway so I love having an excuse to go in to buy supplies: elastic bands, squeezy bottles, etc...

I buy my plain white pumps from a great place on Cheshire Street just off Brick Lane in London – £5 for a pair and the chirpiest customer service you could ever hope for.

Cheshire Street is also a good place to visit for high quality duvet covers and pillowcases. They are recycled from hotels.

H&M Home is great for good quality cotton cushion covers. www.hm.com

The Clever Baggers. I bought 100% cotton cushion covers from here, and you can also get tea towels. They have seconds too, so you can buy slightly wonky tea towels very cheaply. www.thecleverbaggers.co.uk

Ebay is brilliant for finding white cotton caps – laces can be bought cheaply here too. www.ebay.co.uk

Ikea is also a good place to get bedding to dye – just make sure you are buying 100% cotton. www.ikea.com

Primark has multipacks of baby gros as well as socks. www.primark.com

THANK YOU

The biggest thank you to my mum and dad, Angie and Dave King. Thank you for all your advice and help. You have (almost!)* always encouraged me to be creative and messy at home – something that has greatly shaped my life and my career. I am very lucky to have such wonderful, supportive parents x x

Lizzie Mayson – you were a pure joy to work with. I am in awe of your photography skills. It was amazing to get the chance to work on a project with a best pal, even better a best pal who is mega talented. Thank you Lazlo!

A huge thank you to Amy Christian at Pavilion Books, for finding me and trusting me to write a book. Something I never dreamed would happen. I thought the original email you sent was a mistake or spam! It has been a pleasure working with you. Thank you for allowing me such creative control. Thank you also to Ione, Michelle and Katie at Pavilion. It has been a long process and I really appreciate all your help.

Claudia Young, thank you for agreeing to be my agent and always being on the end of the phone when I needed advice. It felt brilliant to know that you were on my team!

Janet Slingsby for giving such good writing advice, and for reading my words so carefully. If you hadn't told me that it's ok to write in your own voice I don't think this book would have ever been finished!

Katy Pritchard for helping with the shoot and being the most organised person I know. You made the whole day so much easier. Also for being encouraging about my writing, I was very nervous to show anyone. Thanks best bud.

Marshal Darling for being so very supportive and kind. You have had to listen to a lot of tie-dye talk! Thanks for making me delicious dinners and unloading all my props from the car when I was too exhausted. You're a dream.

Ellie Jauncey for lending me lovely things to use in the shoots, and for being a kind ear in the studio. Thanks to you and Anna Day for all your book advice. It was great to share a studio with experienced authors.

Cesca Dvorak for introducing me to Shibori, and lending me tie-dye books. It was lovely to talk tie-dye over a cuppa with you.

Thanks to Dylon for being so generous. I loved getting my dye packages in the post!

To everyone who has come to a Get Rich or Tie-Dyeing workshop, THANK YOU! I hope you have enjoyed your experiments in the world of tie-dye!

*except when I cut through the new kitchen table with a scalpel…

First published in the United Kingdom in 2017 by
Pavilion
1 Gower Street
London
WC1E 6HD

Copyright © Pavilion Books Company Ltd 2017
Text and pattern/project copyright © LIZZIE KING 2017

Photography by Lizzie Mayson

ISBN 978-1-91090-474-9

A CIP catalogue record for this book is available from the British Library.

2 4 6 8 9 7 5 3 1

Reproduction by Mission
Printed by 1010 Printing International Ltd, China

This book can be ordered direct from the publisher at www.pavilionbooks.com

PAVILION

Whatever the craft, we have the book for you –
just head straight to Pavilion's crafty headquarters.

Pavilioncraft.co.uk is the one-stop destination for all
our fabulous craft books. Sign up for our regular
newsletters and follow us on social media to receive
updates on new books, competitions and interviews
with our bestselling authors.

We look forward to meeting you!

www.pavilioncraft.co.uk